Tōji Temple, Five-story Pagoda, Kyoto

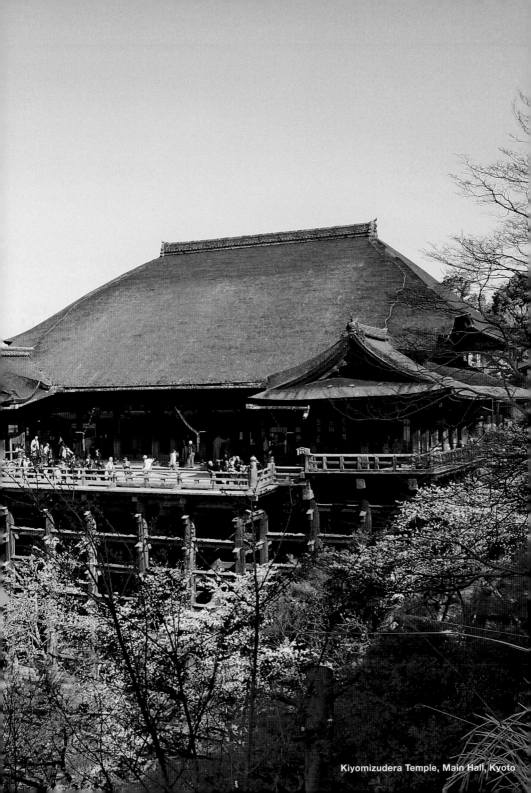

Kiyomizudera Temple, Main Hall, Kyoto

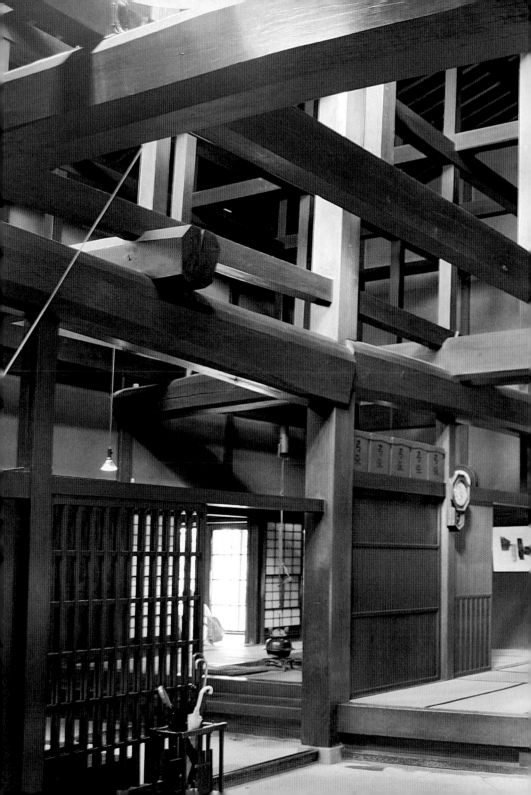

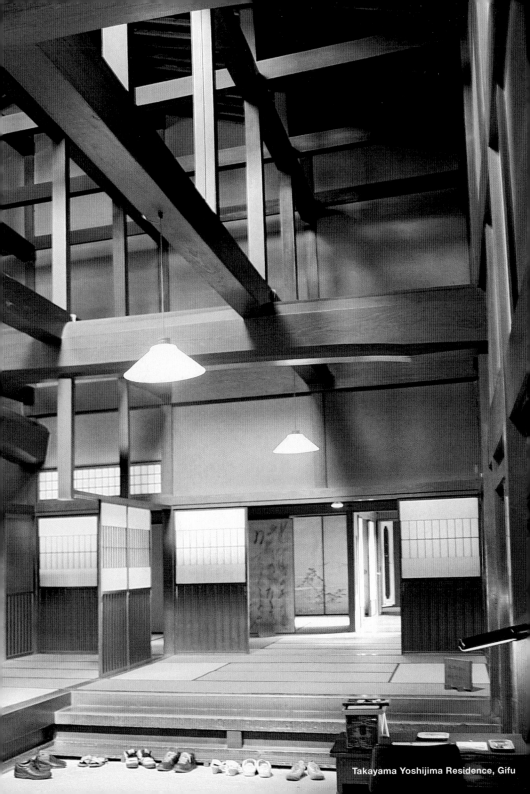

Takayama Yoshijima Residence, Gifu

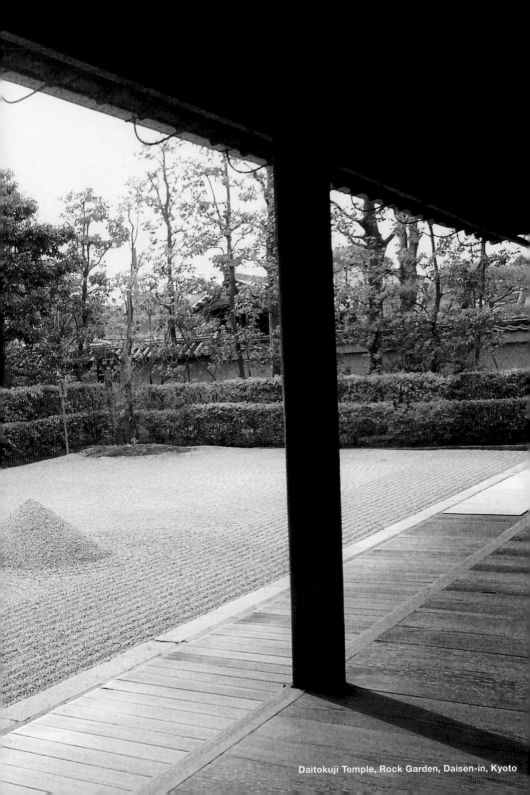
Daitokuji Temple, Rock Garden, Daisen-in, Kyoto

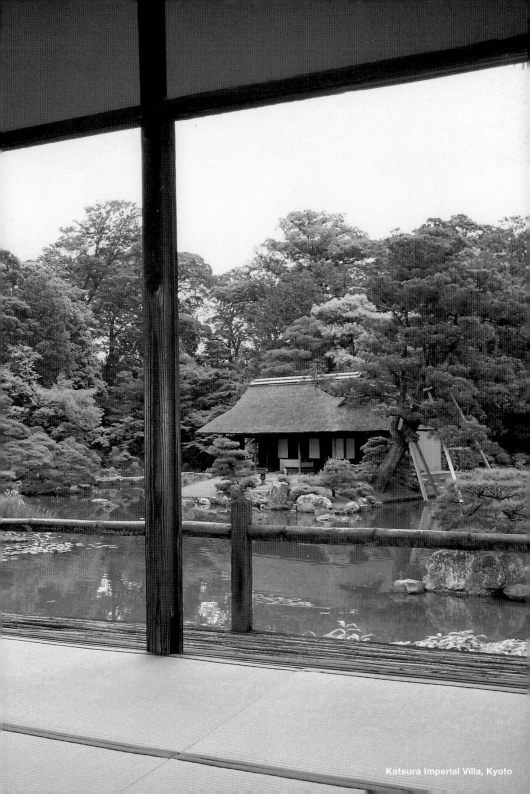

Katsura Imperial Villa, Kyoto

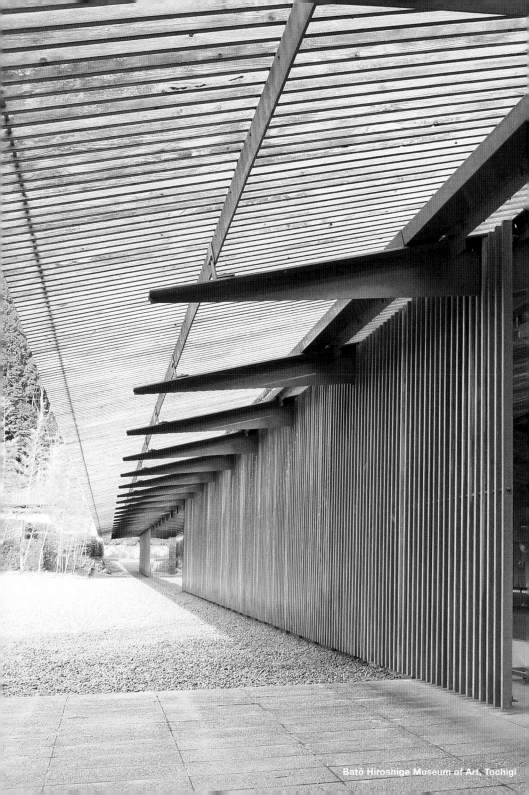

Batô Hiroshige Museum of Art, Tochigi

# JAPANESE CREATIVITY

—

# CONTEMPLATIONS ON JAPANESE ARCHITECTURE

**YUICHIRO EDAGAWA**

jovis

# Foreword

Yuichiro Edagawa's book is an epoch-making work that describes what "Japaneseness" is. What lies at the root of Japanese creativity and its architectural artifacts? By analyzing a wide variety of exemplary buildings from the sixth century to the present, Edagawa determines twelve distinctive characteristics of Japanese architectural creativity and composition, including intimacy with nature, importance of materials, bipolarity and diversity, asymmetry, devotion to small space, and organic form. Most of all, this book explains that distinctive features of Japanese architecture derive from the design method "parts precede a whole," which is an unprecedented architectural way of studying.

It is significantly important to publish this work in English and to appeal to a worldwide audience. There have been very few studies on Japanese architecture written in English and because of the recent rise of interest in Japanese architecture, it has been a great challenge to promote the understanding of Japanese architectural wonders. In this sense, the English publication will be a great contribution for foreign scholars who are interested in Japanese architecture and will also respond to the expectations of many foreign people interested in exchange with Japanese culture.

Kengo Kuma

# Introduction

In 2008 in Germany, I published a photo and interpretation book titled *Japanese Identities: Architecture between Aesthetics and Nature* introducing Japanese architecture to a worldwide audience in the English and German languages (Edagawa 2008). The first page opened with the following photograph and words:

> The publication was my humble attempt to show people overseas the beauty and magnificence of Japanese architecture. I wanted to introduce scenes created by Japanese people that are characteristic of Japan, show the original creativity of the Japanese, and that have cultural and/or historical impact, and which I considered beautiful.

The book was well accepted as a guide book for Japanese architecture and was widely distributed around the world. But within myself, there existed the thought that the level of the book didn't dig deep enough to introduce Japanese architecture and culture.

As an architect, I have been given many opportunities to design various buildings, and at the same time, I have tried to experience as much architecture as possible. Observing a number of old and new buildings in detail, I cannot help but sense a certain nature such as basic stance of creativity of the Japanese continuously streaming through them. This is the inner sensibility of the Japanese, which might be an inherited gene and DNA among us. There is an apparent commonality in what the Japanese regard as beautiful, comfortable and what holds us in awe. This is what I want to dig into.

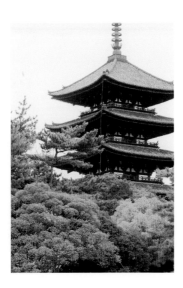

But how can I describe and explain this in detail? By focusing on Japanese architectural artifacts that strongly exemplify a Japanese identity and by describing distinctive characteristics that are at the source of an architectural "Japaneseness." In this book, I will deepen the understanding of the relativity of these characteristics and what are behind Japanese-like perceptions. I will also try to refer to the kind of architecture to which these characteristics might lead.

By studying the distinctive features of Japanese architecture, I want to:

- organize existing ideas and studies on Japanese architectural characteristics
- come up with new relations and interpretations between and behind these features, through new comprehensive and bird's-eye views, in addition to the individual perspectives of existing ideas and studies
- create a more essential understanding of Japanese identities through new interpretations and viewpoints
- verify what kind of architecture Japanese identities might create
- find a way to interpret and explain Japanese identities as a whole

What we especially have to take into consideration is that, when we talk about the distinctive features of Japanese architecture, it is likely that basic attitudes of creation, such as intimacy with nature and emphasis on natural materials, and morphological

features, such as asymmetry and organic forms, are pointed out. Sometimes, the peculiar sensitivity of the Japanese, such as the concept of *oku* (inner space) is referred to. Furthermore, in the background of these features, "certain Japanese ways of thinking and perceiving" seem to have a great influence. How can we describe what they are?

When we discuss "certain Japanese ways of thinking and perceiving," we should refer to *A History of Japanese Literature* by critic and author Shuichi Kato (Kato 1980). Kato's book is a masterpiece that describes the dynamism of Japanese mental activities and refers to the innermost depths of the heart of the Japanese and their indigenous views of the universe. This book has been translated into many languages, including English, French, German, Italian, Chinese, and Korean, and it is regarded as a must-read in the study of Japanese culture. What Kato describes is extremely suggestive for considering the characteristics of architectural space.

In his later work, *Time and Space of Japanese Culture*, in which he summarized what he had in mind on this subject, Kato writes:

> The Japanese look at the total world from "here," they do not look "here = apart of the world" from the total world order. The whole is created by piling up parts rather than coming up with a pile of parts by dividing the whole. Namely, parts precede the whole. (Kato 2007)

This idea is the same as my own understanding of Japanese architecture. That is to say, Japanese architecture in general "develops

from parts to a whole, not from a whole to parts." The Japanese process of creation starts from parts and ends up as a whole that combines these parts. It thus bears the characteristic that "parts precede a whole."

In this book, I will focus on the notion that "parts precede the whole" by asking several questions. What does this mean? How is it brought about? What influence does it have? And what results does it bring about? By doing this, I will deepen the understanding of the structure of Japanese architectural creation and its background through analyzing and verifying Japanese architectural sensitivity, its ways of creating ideas, and its outcome forms and characteristics. Thus, I will find a route to explain the distinctive features of Japanese architecture.

Many architects and scholars have studied the Japanese way of design, but it is likely that these studies were undertaken individually and separately. What I am trying to do is to organize existing ideas and studies and describe its various features in a parallel and crossing manner. In the end, I hope to uncover a particular Japanese creativity that lies at the root of our architectural artifacts.

# CHARACTERISTICS OF JAPANESE ARCHITECTURAL CREATIVITY

# Intimacy
# with Nature

One of the most distinctive features of Japanese architecture is no doubt its close relationship with the surrounding natural environment. Architecture, in harmony with its natural surroundings, is treated as if it were integrated with them. Japanese architecture is not intended to surpass nature, but it can be said to coexist with nature. This is to say, in general, nature in Japan is gentle and people appreciate most of the gifts of nature, and therefore our ancestors followed the way of symbiosis with nature. This is in great contrast to architecture in the Western world, which tends to be isolated from nature and appears to want to assert itself over nature.

In his work *Characteristics of Japanese Architecture,* Hirotaro Ota describes Japanese architecture as follows:

> Japanese architecture is not intended to confront nature; rather, even though it is man-made, it is considered to be just a tiny scene of nature like a tree. ... Japanese architecture shows a humble stance with its friendly attitude toward nature rather than with its strong presence as an individual. What Japanese architects aimed for was not a highlighted imposing structure, but a humble structure harmonizing with nature. (Ota 1954)

What do Japanese people look at and feel when they stand in front of an architectural structure? Ota's description follows:

> Here is a famous *waka* poem by the twelfth-century monk Saigyo Hoshi. This poem was read when he visited the Grand Shrine of Ise: *nanigoto no owashimasu kawa shiranedomo,*

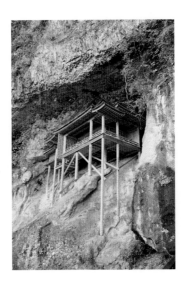

*katajikenasa ni namida koboreru* (loosely: I do not know what god there is, but feeling utterly blessed, I am deeply moved to tears). (Ota 1954)

What impressed Saigyo so deeply? Was he moved by the beauty of the architecture itself, which Bruno Taut described as "the greatest piece of creative architecture in the world"? Probably not. More likely, Saigyo was impressed by the thick cedar grove, the simple shrine building made of plain wood, and, moreover, by the harmony between the architecture and its environment.

Thus, it is needless to say that Japanese architecture bears great relevance to the surrounding environment and has a strong symbiotic attitude to nature. And it is natural that, in the process of creating each piece of architecture, this symbiotic attitude to nature leads to more attention being paid to each part of the structure to allow it to adapt to the surrounding nature. In this chapter of the book, I study various pieces of architecture that are symbiotic with nature in order to attempt to study the basic influences that are brought about by the symbiotic attitude of the Japanese to nature.

### Nageiredo Hall, Sanbutsuji Temple, Tottori Prefecture 2

This is one of the most representative examples of this attitude, which clearly shows the harmonious relationship between nature and Japanese architecture. The hall stands in a natural cave half way up the steep cliff of a sacred mountain. *Nageire* means "to throw in." It is not certain how this hall was built, but legend has

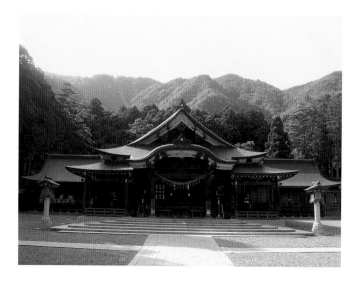

3   Worship hall of
Yahiko-jinja Shrine
and holy Mount Yahiko
(rebuilt in 1916, location:
Yahiko Village, Niigata
Prefecture).
This worship hall exists in
complete unity with the
holy mountain in the back-
ground. It is composed as if
it were the point of contact
with god.

it that after being built on level ground, it was thrown into the spot where it stands by the dharmic power of the founder En no Gyoja. Ancient Japanese mountain worship was combined with Shinto and foreign Buddhism, and temples were built on steep mountains so that the priests would suffer ascetic lives.

On the one hand, the hall was built in the graceful Heian period (794–1185) style, a characteristic of which is the elegantly curved roof. On the other hand, the length of various pillars supporting the hall expresses well the powerful and wild nature of this peculiar architectural structure. A close study of the wood used for the building and the statues inside revealed that the hall was built in the second half of the eleventh century.

Built in a natural cave, the hall has not been exposed to rain, snow, or strong winds. Due to the fact that the cliff faces north, the adverse effects of sunlight have also been avoided. Thus, the hall has survived for a thousand years and is now designated as a National Treasure.

On my visit to the site, I recognized that this is certainly a Buddhist hall and representative of Buddhist architecture. But from its appearance, nestled in nature, its existence as a piece of architecture was quite obscure. It rather became clear, in response to various requirements that nature imposed, that the building exists as a result of how its parts, each of which conforms to natural conditions, was assembled together.

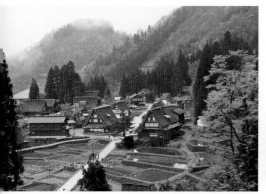
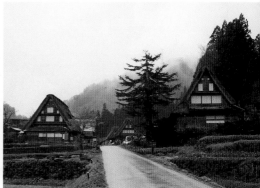

4 Aikura community in Gokayama.

5 *Gassho*-style houses in Gokayama.

### Yahiko-jinja Shrine, Niigata Prefecture 3

Visiting Yahiko-jinja Shrine for the first time, I was strongly impressed by the intimate relationship, illustrated in this photograph, between the mountain in the background and the shrine buildings. The mountain and the worship hall seemed to be in complete unity, and when I prayed to the God *Ame no Kagoyama no Mikoto*, I felt strongly that I was praying to the sacred mountain. At 638 meters high, Mount Yahiko is within the sacred boundary of the shrine, but it seemed as if the mountain itself were the principal image of the shrine.

Being polytheistic, the Japanese tend to cherish holy feelings for high mountains, huge rocks, tall trees, etc., as well as supernatural phenomena.

Thus, it was typical for a shrine to be built at the base of a distinctive mountain; together the shrine and the mountain create a more divine atmosphere with synergistic effects.

Here, the architecture emphasizes the holy existence of the mountain and is merely a part of the whole composition. The attitude that treats architecture as a part of a whole rather than as a leading role greatly influences the way the building exists as an architectural structure.

### Gokayama *Gassho*-Style Houses, Toyama Prefecture 4, 5

Here is a small village in the rural mountains where there are twenty characteristic *gassho*-style houses. Most of them are 100 to 200 years old, but the oldest is said to date back 400 years. The

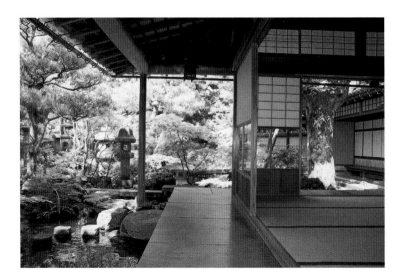

overall view shows a typical small mountain village, like those formerly found all over Japan, which brings to mind a kind of yearning.

*Gassho* means to clasp one's hands, and this is meant to express the characteristic shape of each house's enormous roof. The roof slopes at an angle of about sixty degrees, which means the snow easily slides off. The roof frame is lashed together with rope and twisted hazel boughs, and no nails are used. Architecturally, *gassho* style is highly rational, having a strong structural design, and at the same time, it provides ample space inside for daily living and working (with three attic floors).

In these *gassho*-style houses, symbiotic lives are possible through the efforts to comply with natural laws, the use of natural materials, and a rational way of life. As a matter of course, the lifestyles of those who lived in these houses would have led to considerations of how the parts of a building should be related to daily activities and how inhabitants could construct a building utilizing natural materials, rather than to how the building should be as a whole. This way of thinking would certainly have great influence on an architectural design process in which parts precede the whole.

### Nomura Residence in Nagamachi District, Kanazawa, Ishikawa Prefecture 6

In the heart of Kanazawa, only a ten-minute walk from the busy city center, one finds this quiet, rather sentimental quarter. Several hundred years ago, in feudal days, middle-class samurai lived

**6 Nomura Residence in Nagamachi District.** Eaves and *engawa* (veranda) achieve an intimate relationship between inside and outside. The building is *ganko*-shaped (flight form of wild geese), seeking an extension of contact with the outdoors. The design of each part of the building is more important than the overall shape of the whole.

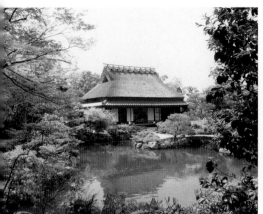
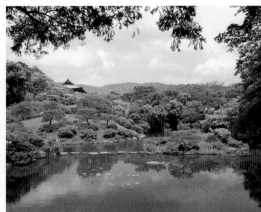

7   Isuien front garden (completed around 1670). This is a strolling type of garden with changing views as the walk progresses. The garden as a whole is an outcome of various components such as the architecture, a pond, a bridge, trees, and flowers.

8   Isuien rear garden (completed around 1900) and borrowed scenery. It is difficult to identify the boundary between the garden and the borrowed scenery. The garden is completely incorporated into the surrounding natural environment.

here. The continuous thick earthen walls preserve the characteristic atmosphere of a samurai housing district.

Within this district, a charming garden is preserved at the former residential site of the Nomura family, one of the samurai leaders. This Edo period home offers an enclosed garden with waterfalls and a carp pond extending below the *engawa* (veranda) of the main guest room. The garden is completely hidden—enclosed by the walls as a perfect garden sanctuary. The *Journal of Japanese Gardening* ranked this garden as number three in Japan, after the Adachi Museum of Art and Katsura Imperial Villa. Here, one can realize just how intimate with nature the Japanese way of living has been. Inner and outer boundaries are so ambiguous.

When I put myself in this space, I strongly feel that Japanese architecture is meant to be created from its parts in relation to the surrounding nature, without being conscious of architecture as a whole. Existence and insistence as a whole are so vague. Sitting in this space, I will never be conscious of the overall shape of the structure.

### Isuien Garden, Nara 7, 8

This is a secret spot in Nara where one can enjoy utter quiet and solitude because it is not so well known. The garden consists of two parts—the front garden (completed around 1670) and the rear garden (completed around 1900).

The front garden is a strolling type of garden with changing views as the walk progresses. The rear garden is a superb example

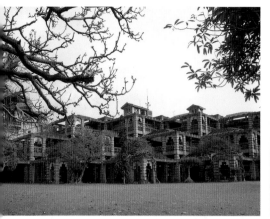
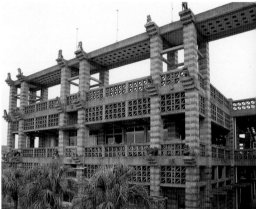

of incorporating borrowed scenery. The two gardens are connected by a narrow passage and visitors are surprised by the sudden widening of the vista as they approach the rear garden. The roof of the Great South Gate of Todaiji and the multiple layers of green mountains in the background offer wonderful views, which have probably been the same since the completion of the garden.

In order to appreciate a Japanese garden, it is essential to sharpen the senses, take time, relax, and contemplate whatever thoughts arise. Therefore, it is very important to sit down and be comfortable, and to enjoy a cup of tea or even a tea ceremony in the open air in order to truly experience the essence of a Japanese garden, namely, the condensed world of nature.

The rear garden is a typical borrowed-scenery garden. It is meaningless to distinguish borrowed scenery from the actual garden. While the garden is completely artificial, it is impressive that its creation is so natural that it is fully integrated with the natural scenery. In the case of a borrowed-scenery landscape, the garden design is merely a part of the whole scene.

### Nago City Hall, Okinawa Prefecture

This is a city hall building in Okinawa. Its distinct façade—with *shisa* (a guardian decoration) and a pink exterior finish—is very impressive. Since its completion thirty-five years ago, the pink has faded slightly, which has resulted in a nice harmony with the deep green of the surrounding trees. Gentle and comforting breezes

9 Nago City Hall surrounded by thick green trees (completed: 1981, location: Nago, Okinawa, Architect: Team Zoo).
The human-scale divided façade creates an intimate atmosphere.

10 Exterior finish utilizing local color blocks.
The distinct façade with *shisa* (guardian decorations) and a pink exterior finish using local materials.

flow through the open-air corridors and terraces that connect all
of the offices in use. 9, 10

Team Zoo, the architects who won the competition for Nago City
Hall, practice their design work according to unique design prin-
ciples, including expressing local identities, stimulating the five
human senses, and enhancing and enjoying nature. Thus, their
design for the building featured distinct characteristics that were
highly admired by other architects who were facing the limits of
functionalism and rationalism in modern architecture. Caring for
and emphasizing the local conditions was the breakthrough that
everyone had been looking for.

Moreover, during the early 1980s, Team Zoo was trying to design
a building with as many ecological features as possible: deep eaves
to shade against strong sunlight, maximum-height windows and
openings to let in natural wind, open-air corridors for natural
ventilation, terraces and roof gardens to cut heat loads, etc. Team
Zoo was able to achieve all of these ideas from the very beginning.
Here, they included their design intentions in every part of the
building and succeeded in completing such a charming piece of
architecture as a whole. 11

So far, I have described how Japanese architecture has maintained
a symbiotic approach to nature through history. The nature of
Japan—its landscape, terrain, climate, seasons of the year, vegeta-
tion, etc.—is extremely diverse and its situations vary infinitely.
In order to coexist with nature, an architectural structure must

adapt itself to change and its location. Therefore, a piece of architecture must not seek a uniform figure as a whole; rather, its parts should cope with the given circumstances. It is obvious that these conditions will lead to the consideration that the individual parts of a structure have priority over the structure as a whole. Nature is an aggregate of various components. To maintain a harmonious relationship with nature, each part of an architectural structure must be compatible with the diversity of nature. One cannot create a structure that is symbiotic with nature without paying the most precise attention to every part of it.

# Importance
of Materials

A few years ago, Japanese food—specifically, "Japanese traditional food culture"—was registered as a UNESCO Intangible Cultural Heritage. The essence of the exquisite charm of Japanese cuisine is being able to enjoy the taste of the ingredient itself, to take advantage of the appearance, fragrance, and feeling on the tongue of the ingredient as it is, through the five senses. Japanese people use the very best ingredients, with no processing at all, and this is a typical example of the active sensitivity of the Japanese. By contrast, to take French cuisine as an example, because many of its ingredients are braised with a lot of spice, we can hardly tell what they are. It is likely that ingredients do not keep their original form. As in the case of cuisine, the handling of materials thus differs greatly in Japan and in the West. Do we live in accordance with nature or with an overbearing attitude toward nature? The difference in our way of life leads to characteristic contrasts.

I will look at how these differences appear in the field of architecture. In the following examples, I will refer to how each architectural material is handled and, as a result, to what kind of architecture is created utilizing those materials. Through comparisons of Japanese and Western examples, I will try to examine how particular the Japanese have been about materials themselves.

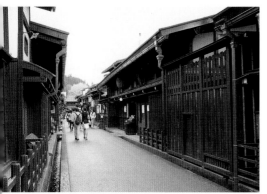
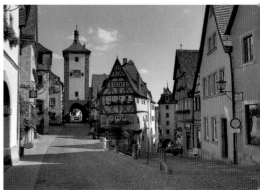

## Townscape of Two Medieval Towns

1 The Japanese being particular about materials themselves. 12, 13

Sanno-machi developed as a merchant town at the center of Takayama castle town, which was called the "Little Kyoto of Hida." As evidenced by the fact that it was designated as a "Preservation District for Groups of Traditional Buildings" by the Japanese government, the district conserves its buildings and townscape from the late Edo period.

By contrast, the old town of Rothenburg in Germany, also known as a medieval jewel, preserved the exact historical townscape in its postwar reconstruction. Because Rothenburg is close to the rich timber-producing areas of the Schwarzwald (the Black Forest), it has a lot of wooden structures that are similar to Japanese culture, but the design appears to be totally different.

In Western Europe, wood is mostly covered by colorfully painted plaster, while in Japan the wood itself is highlighted by the characteristic design of woodwork, and the overall simplicity plays the key role. By comparing these two examples, it can be seen that there is a great difference in the way they handle and insist on materials.

12 Sanno-machi, Takayama, Gifu Prefecture.
Here it is clear how the Japanese insist on wood; characteristic lattice works continue on both sides of the street. Painted in a blackish color that is a mixture of red iron oxide and persimmon soot, the buildings preserve the goodness of wood as it is.

13 Rothenburg, Germany.
Most of the buildings in the town are wooden structures; nonetheless, they are completely covered by colorfully painted plaster. As a result, they lack the characteristics of natural wooden buildings.

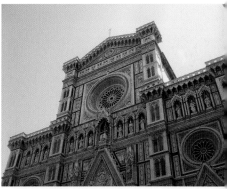

**14  Katsura Imperial Villa, Kyoto (constructed over several decades after 1615).**
Wood, bamboo, Japanese paper, plaster, etc. insist on their existence as they are. Differences in their natural qualities bring about the deep flavor of the exterior finish.

**15  Santa Maria del Fiore, Firenze, Italy (completed: 1436, architect: Filippo Brunelleschi).**
This building is surprisingly colorful and beautiful. This is why it is referred to as the "Cathedral of the Flower." The exterior wall is covered with finely cut pieces of colored marble that are treated just as colored pieces, with no claims as stone material.

## Handling of Exterior Finishing Materials

2 Each material insists upon its presence. 14, 15

The buildings at Katsura Imperial Villa in Kyoto are in the *sukiya* style, which utilizes the very best of diverse natural materials and enjoys their refined taste. As seen in the photo, wood, bamboo, Japanese paper, plaster, etc., insist on their existence as they are and thus express a simple and delicate beauty.

By contrast, in Florence, the Renaissance Cathedrale di Santa Maria del Fiore (Cathedral of Saint Mary of the Flower) owes its glamorous beauty to the colorful marble decoration of the exterior finishing. Here, marble, cut into tiny pieces, loses its original stone-like characteristics. The marble cuts are merely built into the wall decoration and engraved as colored pieces.

This is a typical comparative example in which major differences are found in the handling of materials in Japan and in the West.

## Handling of Interior Finishing Materials

3 Materials bear clear identification of insistence as a part of architecture. 16, 17

The interior design of the magnificent Alhambra in Granada, Spain, which is a highlight of Islamic culture, is simply overwhelming. The numerous tiles, stone pieces, and plaster works

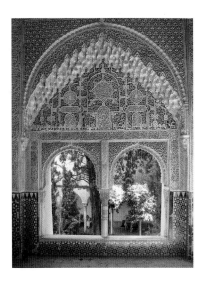

(stucco) have created a unique world, and the way in which the materials have been handled is quite similar to the methods in the West. Numerous pieces of various materials are used, but the total form is the major concern, and the goodness of each material itself is therefore ignored. The constructions could be made of other materials.

By contrast, this is a typical wealthy merchant's house in Takayama, which was rebuilt by a master carpenter after a fire in 1907. The most attractive feature of this structure is the space of the shop area inside. After stepping into the house, one is greeted by this fascinating void. The earthen area and adjacent tatami rooms seen in the photograph were for business use. The dynamic structure of the center pillars, flying beams, and posts were symbols of the solidity and reliability of the business. Thanks to the sunlight from the high side-windows, the entire space is bright and comfortable. The pillars and the beams are covered with a thin coating of lacquer, and one can appreciate the beauty of the fine-grained wood.

As you see in this case, the wood simply insists on being itself and plays the main role in this space, and this is a main characteristic of Japanese architecture.

These three examples show that the Japanese insistence upon materials in architectural creation led to the development of Japanese architectural characteristics.

16 **The Alhambra in Granada, Spain.** Arabesques and *muqarnas* (ornamented vaulting) around the windows and on the ceiling are the highlights of Islamic art. They are made of numerous tiles, stone pieces, and stucco.

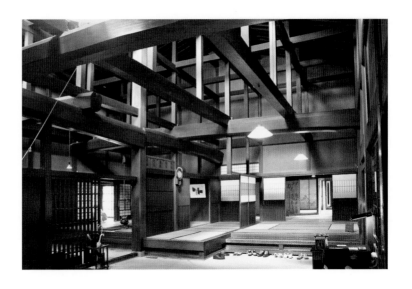

Namely: 1  The Japanese insist on materials.
&darr;

2  Each material insists upon its presence.
&darr;

3  Each material bears clear identification of insistence as a part of the architecture.

In the process of Japanese architectural creation, each material as a part of the architecture is thus considered to insist upon its role, and the total image of a structure as a whole to be created thereafter.

By contrast, the opposite of the logical development mentioned above may also be true.

Namely: 1  Each material bears clear identification of insistence.
&darr;

2  Each material insists upon its presence.
&darr;

3  The Japanese insist on materials.

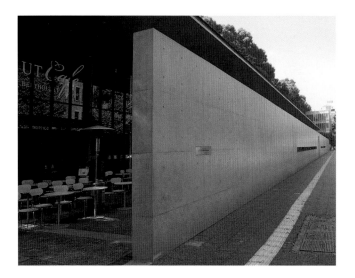

In his work "Characteristics of Japanese Architecture," Hirotaro Ota says: "All structural materials appear outside and they become design materials. The Japanese are fond of plain woodwork without any coloring. Therefore, the quality of the material immediately affects the beauty of the architecture. For this reason, fine-grained wooden materials are preferred and the regard for materials is extremely deep" (Ota 1954).

Nonetheless, this deep interest of the Japanese in materials has great influence on the fact that the Japanese, in their creation of architecture, pay great attention to materials, and it is likely that any architectural structure will be designed from its parts rather than as a whole.

### Fukutake Hall, The University of Tokyo, Tokyo

Tadao Ando is synonymous with exposed concrete. From the beginning of his architectural career, Ando has devoted himself to the use of fair-faced (good-quality) concrete finishing. Ando himself describes the process as follows:

> I have been considering whether there is an architectural expression that is stoic and static while also reaching out to the human spirit, that is quiet while also having a strong impact. In particular, concrete cast on site represents the quality of manual work. Therefore, I have been working in order to create concrete that is stoic but also speaks to human handwork.

18, 19   Concrete wall in front of Fukutake Hall. (completed: 2008, location: Tokyo, architect: Tadao Ando). The beauty of this fair-faced concrete finishing and the long slit on the wall show an extremely high technical level of treating concrete.

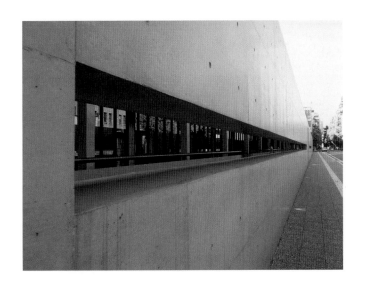

When I first saw a cast-on-site concrete building by Le Corbusier, I thought this is not possible in Japan. To speak of the nature of the Japanese, they are fond of delicate and highly accurate finishing. When I started my office and let my clients see the concrete buildings, they all refused saying ... ridiculous! What I considered was how I could create precise concrete. Once I had been successful, the clients could be convinced. Workers should always do their best, which has much to do with Japanese nature. In such circumstances, I tried to grasp the Japanese mentality, and thus I was able to be acknowledged. (Nikkan Kensetsu Tsushin Shinbunsha 2004)

Ando's words allow us to understand how he has been struggling with concrete and how committed he is to the material. 18, 19

Walking along this long concrete wall in front of the University of Tokyo's Fukutake Hall, what I had in mind is that Ando at first came up with this wall, and—being committed to concrete—he decided to see what he could actually do with the material. The wall, which is more than one hundred meters long, is not merely a wall. It is the outcome of challenging the limits of the on-site casting of concrete. The Japanese recognize the value of the pursuit of limitation, namely, shape, precision, and the beauty of cast-on-site concrete. Ando says, "From the point of view of the Japanese temperament, highly delicate parts and precise finishing are more preferable." This is the wall that achieved these qualities.

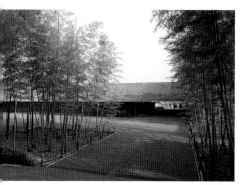
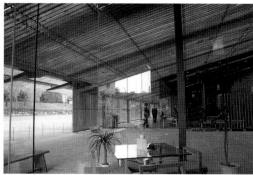

And the willingness to devote all of one's energy to the wall in front of oneself is the basis of the creative attitude that creates a whole from parts.

### Bato Hiroshige Museum of Art, Tochigi Prefecture 20, 21

This is a museum in Bato, which is a town about 150 km north of Tokyo. The museum was built to accommodate the original works of *ukiyo-e* master Hiroshige. Kengo Kuma's design expresses the artistry and tradition of Hiroshige by means of a traditional yet restrained exterior. With its big gabled roof, deep eaves, and latticed walls, the building blends into its rich natural surroundings. In fact, the roof, the walls, and the entire building are completely wrapped in lattice work, which is all three centimeters by six centimeters in size, at a pitch of twelve centimeters, and made from local cedar trees. Thus, the natural light can be appreciated wherever necessary. Local materials such as handcrafted paper walls and local stone paved floors are also used for the interior. Kuma insists on "defeated architecture," which means not being self-assertive but giving way to the environment and to the history, culture, and local materials of the site. Therefore, the building designed by Kuma can be appreciated as the charming expression of his interest in traditional Japanese materials and as the pursuit of an environmentally conscious and culturally sensitive architecture.

20 Rear garden and façade (completed: 2000, location: Nakagawa-cho, Tochigi Prefecture architect: Kengo Kuma). A quiet Japanese atmosphere that calms one's heart.

21 Looking out from the cate. The entire building is completely wrapped in lattice work, all of which is three centimeters by six centimeters in size at twelve centimeters pitch and made from local cedar trees.

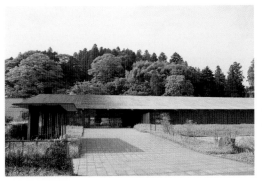

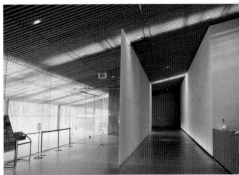

The materials that Kuma sticks to are not limited to architectural materials. In his words, he first focused on the closeness of the mountain behind the building and tried to maximize its existence through the design of the approach way and the entrance of the building. In addition to the exterior local cedar louvers, plenty of local materials are used. A commitment to local materials and their use is the basic stance for creating an architecture that embodies local claims, and this is quite simply the approach that creates architecture as a whole out of individual parts. 22, 23

As can be seen in the examples above, an approach that treats the material itself with great care is typically Japanese. It is understood that this approach puts great importance on materials and that material-conscious architectural parts are the starting point of architectural design.

# Simplicity and Denial of Ornamentation

Japanese architecture features natural materials used as they are (mainly wood), and its form is likely to be simple and lucid. Structural frameworks are not hidden but are meant to express formative beauty. Ornamental elements are limited so that the materials used are appreciated as they are. The technique and know-how of the master carpenters are, of course, essential. Thus, the architecture completely reflects simplicity and purity in nature.

Why are the Japanese fond of such simple architecture? Once, on the occasion of publishing a book of mine in Germany, I was interviewed by a magazine publisher and responded to this question: "Naturally, the Japanese interpretation of the void is not merely emptiness but, more than that, a borderless space for meditation and creativity. Therefore, it is possible to create a pure, simple, sophisticated structure to represent any significant architecture."

It can probably be said that such an abundance of rich imagination and creativity has allowed the Japanese to abandon unnecessary decorations. Simplicity is inevitable with the materials used for construction, so it is possible to exhibit freer imagination and creativity with a minimum of installations.

A tea ceremony room, in which the host is able to express his intention in a once-in-a-lifetime opportunity by arranging a flower or by hanging a scroll in the alcove, is a typical example. With a single branch of cherry tree blossoms, guest and host can share the illusion that they are sitting under cherry trees in full bloom. Because of these spiritual and cultural characteristics, the

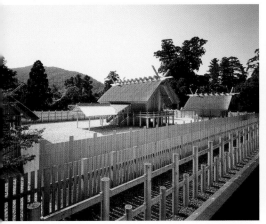
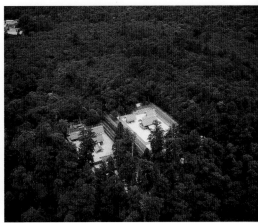

24  Main hall of Inner Shrine (rebuilt every twenty years, which is also the only occasion when the building is exposed to public).
This is the prototype for all buildings in Japan. Although it is a symbol of authority, the nondecorativeness of its nature is remarkable.

25  Inner Shrine being rebuilt on the contiguous lot.
Surrounded by natural forest, this shrine makes one feel this is a place where god descends.

Japanese have respected and enjoyed simple taste without excessive ornamentation.

Below, I will look at examples of architecture that embody this simplicity throughout the ages.

### Ise Jingu Inner Shrine, Mie Prefecture 24, 25

In the midst of the divine forest, which covers one million square meters in the city of Ise, the Inner Shrine stands as it did 2,000 years ago. The shrine buildings are completely rebuilt on the contiguous lot every twenty years to ensure ritual purity, and the old buildings are dismantled. Thus, the original form and technique are preserved with all of their details. Of course, this practice is enormously costly, so Ise-jingu is the only shrine today that is regularly rebuilt, though this was common practice for many shrines in the past.

The style of the main sanctuary building is distinctive to Ise-jingu, and this is the purest and most simplified style of Shinto architecture, which is unique to Japan. This style is said to be the form of a house with a raised floor, which was used to store rice about 2,000 years ago. The impression of the building is extremely simple and linear, using unfinished Japanese cypress, a thatched roof, and pillars erected without foundations in the ground. The sanctuary is enclosed by four rows of board fences and may not be approached by general worshippers.

On his visit to this site, the famed German architect Bruno Taut compared Ise-jingu with the Pantheon in Greece saying, "This is

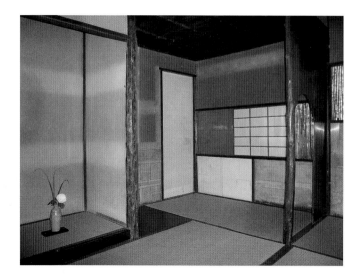

the purest of all buildings in the world. It integrates the fragrant Japanese cypress and the thatched grass of its roof into the most harmonized and ultimate of all structures." This was praise of simple architecture based on the values of modernism.

### Jo-an (Teahouse), Inuyama, Aichi Prefecture 26

The Jo-an Teahouse is a National Treasure, and sitting inside it, one feels a rationality that is precisely calculated. The moderate size of the space, arrangements corresponding to movement, lighting and settings in accordance with what one sees—everything is perfectly arranged. All the ideas—the diagonal wall that widens the view from the host seat; the placement and design of windows, including the skylight; views from the host seat and the allocation of the slope on the ceiling—are simply exquisite. With the roughly finished alcove post and the unique design of the old lunar calendar pasted on the lower part of the walls, the extremely simple interior has become a rich and comfortable space.

As shown in the photograph, this is an unfriendly space without any decoration or color, but once a scroll picture is hung in the alcove, the host and the guests are able to share the common illusion of the picture. This is possible because of the very essence of the tea ceremony and the simple but comfortable design of the space, which deserves the distinction of being designated as a National Treasure.

26 Alcove and host mat (seat) (originally built in Kyoto in 1618, relocated a number of times).
The interior is entirely undecorated and uncolored. The roughly finished alcove post and old lunar calendar pasted on the walls are decorations.

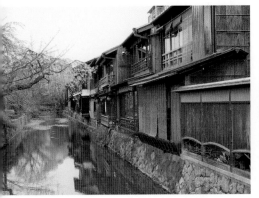
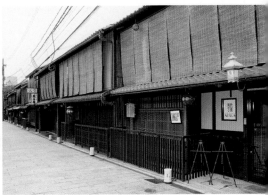

**27  Gion Shirakawa in spring.**
Sprouts of willows and cherry blossoms reflect on the surface of the Shirakawa River, and no decoration on the buildings seems necessary.

**28  Important Preservation Districts for Groups of Traditional Buildings.**
This is a place where one can realize the beauty of Japanese streets. Only natural materials that are slightly processed are used, and there is no artificial decoration.

## Gion Shirakawa District, Kyoto 27, 28

Gion is Kyoto's famous pleasure quarter or Geisha district. Shirakawa is the name of the river. This neighborhood is well preserved with old wooden houses (designated as Important Preservation Districts for Groups of Traditional Buildings), so visitors can enjoy the atmosphere of Kyoto as it was a few hundred years ago.

Gion became a pleasure quarter in the mid-eighteenth century. The teahouses in this quarter where *maiko* and *geiko* girls entertain their guests are in the style of *Kyo-machiya* (Kyoto town houses). *Kyo-machiya* is famous for its small fronts and considerable depth, typically 5.4 meters wide and some 20 meters deep, and is often known as "eel's bed." For these *Kyo-machiya, tsubo-niwa* (3.3-square-meter gardens) are often placed inside the house, which make the houses comfortable not only through their aesthetic reflection but also by bringing in light and air. Small, but built by the workmanship of experienced builders, *Kyo-machiya* reflects the aesthetic sense and comfortable design that developed over the long history of Kyoto.

Delicate Kyoto lattice works and dog barriers continue alongside the streets, and bamboo shades are always hung down on the upper floor. These scenes are typically found in Gion. Such wooden design work has been developed through the use of natural materials as they are without any decorations, and simple taste has had space to develop organically over the ages, taking full advantage of the nature of the materials.

## Katsura Imperial Villa, Kyoto 29

This is typical Japanese style (flying geese pattern): the Middle Pavilion via the Instrument Room to the New Pavilion stand simply in their appearance in the Katsura Imperial Villa. The façades are made of completely natural materials such as wood, bamboo, Japanese paper, and plaster. It is possible to grasp how the delicacy of handling natural materials, the contrast of their colors, and the lightness of thin lines bring about tasteful Japanese beauty.

It is well known that, at Katsura Imperial Villa, Bruno Taut found the essence of architectural modernism, which he attributed to the beauty of the natural materials that were used and to their functions. The fact that he highly praised Katsura, together with Ise, led to the rediscovery of Japanese beauty, which had long been neglected.

## 21st Century Museum of Contemporary Art, Kanazawa, Ishikawa Prefecture 30

The design of this museum started with a completely new concept. Museums have typically had rather closed, authoritative atmospheres, which may have kept people away. Here, the attempt has been made to create a new twenty-first-century museum, which people can visit whenever they want to experience or encounter various events and exhibits. The goal is a museum that is open to the public like a park. Thus, in addition to primary museum spaces, there are community assembly spaces, such as a library, a lecture hall, and a children's workshop.

29  New Pavilion, Instrument Room, and Middle Pavilion (from left).
In contrast to Western architecture, which is full of ornaments, the façade is just a combination of natural materials. The beauty of simplicity without ornamentation is realized.

**44**

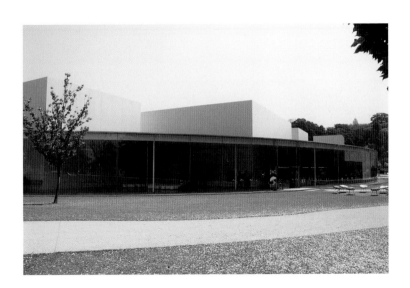

The architectural design is the outcome of a long collaboration between museum staff, artists, and the architect. Circular in form, the building is 112 meters in diameter, with no front or back, no primary façade, but instead with a surrounding transparent glass corridor. The architect attempted to expel all ideas of composition as the basis of her design and minimize what was functionally necessary, so that what takes place in the museum would attract the most attention. The building is as white as possible, with only layers of transparent glass used to create different zones. There are four courtyards within the building that contribute to the bright interior atmosphere, despite the building's size. Here, it is not the main characters who are the objects but the people who move about in the facility. Certainly, this is an unassertive style of architecture, with no decorative element at all.

There is no doubt that simplicity and denial of ornamentation play a big role in the development of Japanese architecture. As described in the chapter of this book "Intimacy with Nature," an intimate attitude toward nature does not require decorative elements. Ornaments are not necessary for architecture that does not assert itself. As for Western architecture, which sticks to architectural styles, it is likely that parts of architecture are regulated from the point of view as a whole. But as for Japanese architecture, which attaches importance to simplicity, it is easy for the preceding parts to come together and form the whole

without being bothered by unnecessary decorative elements. The decorative elements of the whole cannot be designed by the process of the proceeding parts, but "the formative development from parts" is easily realized with simplicity without ornamentation.

# Craftsmanship and Skill of Master Woodworkers

Preeminent Japanese wooden building technology has, of course, been developed by the craftsmanship and skill of master woodworkers of all ages. The legacy of the skills of the master carpenters from the days of Asuka-Hakuho were the foundation of architectural development in Japan. It is rather unique that the Japanese alone used only weed wood for construction.

The thoughtful use of wood, knowing every characteristic of the material, the rational system of structure, the total balance and harmonious proportions, the detailed design, and a sincere attitude toward creation are the distinctive features of Japanese craftsmanship. There is no doubt that craftsmanship has been the essential key for architectural progress and development in Japan.

## Tsunekazu Nishioka (Master Carpenter in Charge of the Reconstruction of the Western Pagoda, Yakushiji Temple, Nara)

The Western Pagoda of Yakushiji Temple was reconstructed more than 450 years after its destruction by the flames of war. It is now colored in bright red and green, and in one sense, it may lack the old charm of Nara. But this is how it used to be originally, and together with the Main Hall, which has also been reconstructed, and the Eastern Pagoda, which has survived since the opening of the temple in the seventh century, it shows the well-balanced harmony of the temple layout. The reconstruction of the Western Pagoda is simply a gift from a master carpenter who knows everything there is to know about a tree. 31

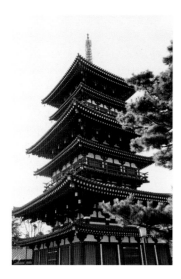

The reconstruction of the Western Pagoda involved various ideas. Each lean-to of the Eastern Pagoda, which is now plastered white, was X-rayed, and it was discovered from the joints that there were latticed windows, which are now restored on the Western Pagoda. The height of the Western Pagoda was raised by thirty-three centimeters in anticipation of subsidence caused by its own weight. And to reduce the total weight, the amount of sand under the roof tiles was cut.

But moreover, it is quite interesting to listen to what Nishioka, the master carpenter who led the total reconstruction, has to say because it shows the wisdom and skill of a master craftsman.

> As for the rafters, it's the same. The rafters for the Eastern Tower are 5 suns × 5 suns [a sun is a Japanese unit of length, approximately 3.03 cm] or 4.5 suns × 4.5 suns, all mixed. But when assembled as a whole, they are in good harmony. The total feeling is so serene. By contrast, for the Eastern Pagoda, the rafters are cut by machine to exactly 5 suns × 5 suns and, as a result, the pagoda looks hard as if cast in a mold.
>
> When really sharp spear-head hand planes are used, even when the whittled surface is exposed to rain, the rain will just wash off. But when electric planers are used, the surface will be soaked when exposed to rain, and as a result black mold will grow. Then the life of the tree as a material is shortened. In this sense, all the wood used for this pagoda is finished by hand using spear-head planes so that it will last for a thousand years. (Nishioka 1981)

31 Reconstructed Western Pagoda (reconstruction completed: 1981, location: Nara, master carpenter: Tsunekazu Nishioka).
According to Nishioka, because the main components including rafters were cut by machine, they are of the same dimensions and look hard as if cast in a mold. Many things need to be carefully considered when handling trees as natural materials.

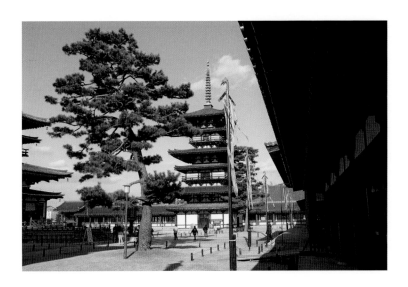

32  Eastern Pagoda,
which has survived since
the seventh century.
The design and reconstruc-
tion of the Western Pagoda
was only possible because
of the existence of the
Eastern Pagoda. In terms
of aesthetical sensibility and
construction techniques,
these were the most ad-
vanced structures more
than 1,300 years ago.

It has been said that the lean-to that makes the pagoda seem to be six stories is a matter of pure design. But the fact is, according to Nishioka:

> Once the roof of the lean-to is set, the swaying of the tower stops at once. It was understood that the tower was stable because of this lean-to. It is impossible to design such an interesting structure. Owing to the existence of the Eastern Pagoda, we were able to design and reconstruct the Western Pagoda. 32

The insights of the master craftsman are astute. Nishioka points out:

> As for the Pagoda of Horyuji Temple, the framework members are thick and not calculated precisely. Whereas for the towers of Yakushiji Temple, the members are thin and the lean-to plays the role of an anti-seismic damper. The difference between the construction periods of the two buildings is only several decades and it is not possible to make such progress in such a short time. The techniques that were used to construct Horyuji Temple probably came in over time from the Korean Peninsula, whereas for Yakushiji Temple it is natural to consider that advanced techniques came in directly from the Tang dynasty of mainland China.
>
> Trees grow naturally, and exposed to sunlight and wind, each tree is different; one is twisted to the right, another to the left. It is important to combine them according to their characteristics so that the torsion strength comes to zero and the tower will not twist. (Nishioka 1981)

The spirituality to draw forth the very best of trees is the skill and the wisdom of master craftsmen and the legacy that they have passed down.

In these passages, Nishioka speaks mainly about materials used and component members and rarely refers to the total design and construction of the tower as a whole. He says in his book, "I have spent all my life struggling with the Japanese cypress and ancient buildings. Therefore, what I say is always about trees." While the passion that is poured into component members and parts of a structure is tremendous, it is as if to say that the total image is brought about as a result.

## Mitsuo Ogawa (Master Carpenter of Ikarugakousha*)

At UIA2011TOKYO (the Twenty-Fourth World Congress of Architecture in Tokyo), an architectural seminar was held on "Japanese Architecture—From the Past to the Present." I had the chance to listen to the following talk by Mitsuo Ogawa, the master craftsman and master carpenter of Ikarugakousha. He is said to be the only direct apprentice of Tsunekazu Nishioka, and he acted as the subleader for the reconstruction of the Western Pagoda and the Main Hall at Yakushiji Temple.

> For the purpose of erecting a pagoda or a hall of a temple, buy a mountain as a whole, not trees. This means that one should go to the mountain oneself and watch how trees grow before deciding how to use them. One will not be able to tell what kind of a place a tree grew in after it has been turned into

* Construction company specializing in building shrines and temples and in the restoration of cultural properties

lumber. It is necessary to know the soil and the environment in which the trees grew, the direction of the wind and sunlight, whether they grew in the middle or at the edge of a forest. Use trees after achieving an understanding of all these aspects.

Use trees according to the direction they grew in. Trees on the mountain are not able to move. They grow at the place at which they were rooted, therefore, it is inevitable that they are greatly influenced by the restrictions of the environment and the soil. If on a spot where the west wind always blows, the branches will grow against the wind to keep straight. This becomes a peculiarity of the tree. Branches grow in the direction of ample sunlight because trees try to get bigger by producing leaves. These trees have many gnarls. As for these trees, it is much better to use them in the same direction in the building as that in which they grew.

When setting up the wooden framework, assemble the materials according to their peculiarities, not by measurements. This is to say that setting things up according to measurements can be done by any carpenter. Trees have their own peculiarities according to where they grow, therefore, it is important to make the best of their peculiarities when setting up a building. If there is a tree twisted to the right, combine it with a tree twisted to the left, and then in time they become established more firmly.

Nowadays, people do not use trees that are bent and have peculiarities. Rather, I should say they can't use them. They

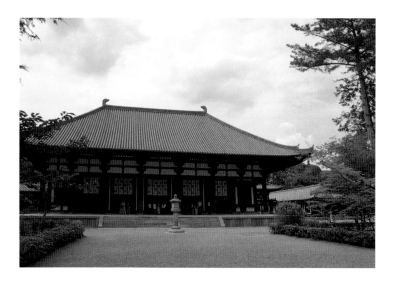

33   The Main Hall after
major Heisei-era repair
work.
Here the original bright red
and green have not been
restored. Thus, it retains the
old charm of Nara.

can only use lumber with a flat surface because they work just on the surface of trees, not on the core. They use only machine-crossed materials. They have nothing to do with the peculiarities. They assemble materials by measurements because no considerations are necessary. Such buildings are naturally weak.

From the title of the seminar, I was wondering what kind of speech master carpenter Ogawa would give. The speech was a strong display of his commitment to materials and of his enthusiasm for the handling of trees. Through the seminar, I was reassured that the tradition of Japan pays great attention to materials (parts) and that the whole is built by assembling the parts.

## Main Hall, Toshodaiji Temple, Nara

The Main Hall of Toshodaiji Temple underwent ten years of repairs that were completed in autumn 2007. Because the structure was completely dismantled for the work, the history of the building since its construction became clear (Suzuki 2009).

Not only priests but also a large number of engineers accompanied Ganjin, the high priest at Daming Temple in China, when he accepted Emperor Shomu's invitation and came to Japan, reaching Nara in 754. They brought with them new styles and technologies. The Main Hall is a building on a grand scale, and it is the largest and most formal structure existing from the Nara period. There are very few examples existing in China and, therefore, when a building from the Tang dynasty in China is restored,

**34  Colonnade on the Main Hall façade.**
Although the hall has undergone repair projects, most of the materials used for this colonnade corridor are from the days of the original construction. This is proof of the legacy of wisdom and technology handed down by outstanding craftsmen.

reference is often made to the design and structure of Toshodaiji Temple.

The Main Hall of Toshodaiji Temple has gone through at least four major repair projects (twice in the Kamakura period, once in the mid-Edo period, once in the later Meiji period). The posts and beams of the main frameworks remain from the time of the building's construction, but the roof was altered completely in the Edo period. The slope of the roof became steeper and, as a result, the roof is 2.5 meters higher than it was originally. So the roof tiles of the Tenpyo era were not as visible at the time of construction as they are now. In any case, although the building has gone through occasional repairs and structural reinforcements, the fact that it remains as it was 1,250 years ago in a healthy state proves the outstanding wisdom and technology that master craftsmen possess. 33, 34

When visiting the site, one will notice the impressive Main Hall standing quietly as if nothing had happened. The Main Hall of Toshodaiji Temple underwent ten years of repairs that were completed in autumn 2007. As for the most recent major repair work, an attempt was made to reuse the original materials as much as possible, which did not reproduce the brilliant colors that had been used originally. The evaluation that it appears "as if nothing had happened" is quite important. The powerful image of the colonnade on the façade, the marvelous framework above, the technology that made it possible to create this structure in ancient days, and the technique and spirit of master

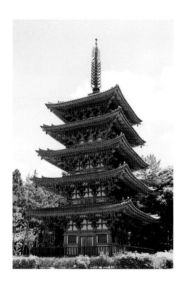

craftsmen that enabled this structure to survive for more than 1,250 years—I could not help paying my respects to all these factors and, at the same time, I was strongly moved and proud of them as a Japanese.

The stunning colonnade and the corridor, which adds depth to the façade, and the brackets that support deep eaves are surely the important components of the building as a whole. But I have the impression that they are not designed as parts of the whole, or rather, that the whole is a result of the bringing together of the pursuit of design and the details of each part.

## Five-story Pagoda, Daigoji Temple, Kyoto

On a suburban hillside outside of Kyoto stands this beautiful Five-story Pagoda, which was built in 951 for the repose of Emperor Daigo. Because of its location outside of the city, the pagoda survived the wartime fires. Although it has gone through a number of large-scale repair projects, it is the oldest remaining wooden structure in the ancient city of Kyoto. 35

The deep eaves and the elegantly curved roofs are characteristics of the pagodas, but because of the wooden structure, these elements were only made possible by the development of the multiple-stepped bracket system, which can be seen clearly beneath the eaves of the Five-story Pagoda. It is worth mentioning that such rational solution techniques also contributed greatly to the aesthetic development of pagoda design.

35   The pagoda stands as it was more than 1,000 years ago (built: 951, location: Kyoto).
The wonder of the multiple-stepped bracket system and the pursuit of technology and design are beautifully accomplished. The partial structure and design come first, and the deep eaves are realized. It is clearly understood that the whole is a gathering of the parts.

Wooden architecture is really an essence of the technique of bringing together wooden materials. There are materials (parts) at first, and the whole is created utilizing most of them. It is not difficult to imagine that the sensitivity that is thus cultivated would have had significant influence on the mechanism of Japanese "parts-precede-the-whole" creativity.

# Bipolarity and Diversity

Because of their extreme ornamentation and brilliant colors, structures at Nikko are often criticized as heretical in Japanese architectural history. But can it really be so? They are surely far from the general image of Japanese architecture. When we refer to Japanese architecture, it is likely that we imagine features that are restrained and intimate with nature.

Rikyu created the Taian Tea-Ceremony Room, which was considered to be the ultimate in "restrained and understated elegance." And, at the same time, Rikyu had much to do with the creation of the Golden Tea-Ceremony Room by order of Hideyoshi. Since ancient times, Konjikido (Golden Hall) has been nestled in the woods at Hiraizumi. Recently, the interior of Phoenix Hall, Byodoin, was created using computer graphics, which showed a world of brilliant colors. So, it was not only Nikko that was brilliantly colored. At the same time as Nikko, the Date clan of Sendai also created a dazzling mausoleum, which was compared to Toshogu Shrine. It was not only a matter of gorgeousness but also of scale. Nobunaga Oda created the huge Azuchi Castle, and the Main Hall of Todaiji was the largest wooden structure in the world until the twentieth century. Furthermore, Nintoku Burial Mound has been considered to be the largest cemetery in the world in terms of area.

The most distinctive feature of Japanese architecture is its intimacy with the surrounding environment, and it is useless to discuss architecture by itself. This is what we have seen so far. But when required to create a completely different world beyond restraints,

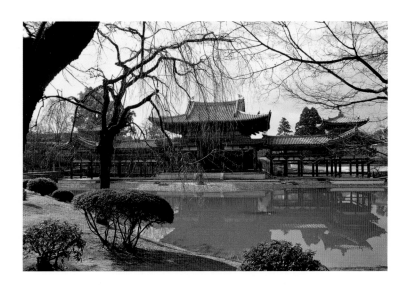

it is natural that an architecture that cannot be categorized would suddenly appear. Such buildings are to be found everywhere.

### Phoenix Hall, Byodoin Temple, Kyoto 36

Without doubt, this is one of the masterpieces created 1,000 years ago by the Japanese. The function of this structure was simply a hall to house Amida Buddha, but the creativity of the designers went far beyond that. They added decorative raised corridors on both sides of the hall and, as a result, the total structure can be compared to the image of a phoenix spreading its wings. The proportions of each part are so well balanced, and the total harmony, including the pond in front, is inexpressively beautiful.

This building was completed in 1053. The year 1051 was believed to be the beginning of the final decline of the Buddha's teachings, and only Amida was believed to have the power to save humankind. Therefore, halls dedicated to Amida flourished, and this Phoenix Hall was a representative example built by Fujiwara, the most powerful noble clan at that time.

The building was designed to reproduce Pure Land (Amida's Paradise) on Earth. It was appreciated from the other side of the pond, where the Fujiwara family sat and prayed to the Amida Buddha, which could be seen when the hall's center doors were open. The hall is elegant and beautiful, full of imagination, showing the very best technique and strong yearnings for paradise.

By contrast, at the time of construction, most of the exterior finishing of the building, including posts and beams, was painted in

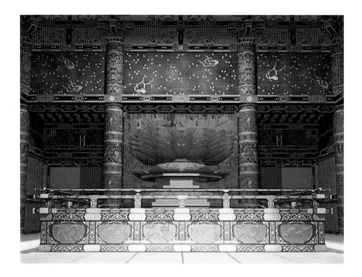

bright vermillion; therefore, the total image of the building was not like the gentle image that we have today. When the restored drawings of the interior were produced by computer graphics, it became apparent that the interior was brilliantly colored and that the colorful world of Buddha had been created. Japanese creativity tends to be restrained and modest, but once energy is concentrated to create something special, it can devote itself to a gorgeous and artificial thing. 37

### Konjikido (Golden Hall), Chusonji Temple, Iwate Prefecture

Far up in northern Honshu, Golden Hall stood quietly surrounded by deep green trees in the precinct of Chusonji. The famous haiku poet, Matsuo Basho, visited this site on his *Okuno Hosomichi* (Narrow road to the interior) travels and read "The rain in May drizzles graciously as if not on Golden Hall." But as far as we know, the hall was already covered in a shelter at the time.

Completed in 1124 by the Oshu Fujiwara clan, it is a small hall, only 5.5 × 5.5 meters, but almost all of it is covered with gold leaf and represents the radiant western Pure Land. It at first stood in woods, but of course it was natural that the gold-leaf-covered hall would be greatly affected by nature and, as a result, it was completely protected by a covering structure one hundred years later during the Kamakura period. Today, the hall is preserved in a glass case that is installed in the concrete shelter building, completely cut off from exterior influences. 38, 39

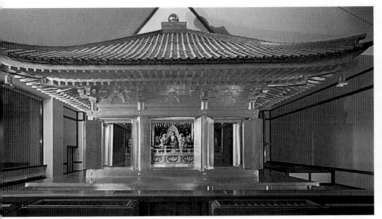

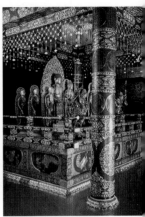

"The inner sanctuary, lavishly decorated with *raden* (inlaid lustrous shells), *maki-e* (gold-sprinkled lacquer), and elaborate carving is the pinnacle of Heian Buddhist art." (Quoted from the official guide of Chusonji Temple)

Ivory from African elephants—not their Asian cousins—is also used. This is how the Oshu Fujiwara clan sought the luxury of the world with their financial power.

There is no shortage of examples, in the East and West, of politically and financially powerful men being charmed by the brightness of gold. But in Japan, among the restrained buildings that are constructed in general, the limitation of gold to one point realizes one special desire. The contrast between the green trees and the Golden Hall standing in the woods—it could be said that this one point of gorgeousness is the outcome of the Japanese artistic sensibility.

### Golden Pavilion, Rokuonji Temple, Kyoto 40

The Golden Pavilion is famous for its completely grandiose beauty, for each of its elegant details, and for its image mirrored on the lake that lies before it. It was originally built in 1398 by the third shogun (commander-in-chief) of the Muromachi period (1336–1573) as a part of a sumptuous villa, which later became Rokuonji Temple.

With a three-story structure, the pavilion is built over a spacious pond and casts its reflection on the water with an effect that is quite remarkable. It is a peculiar structure, with each floor

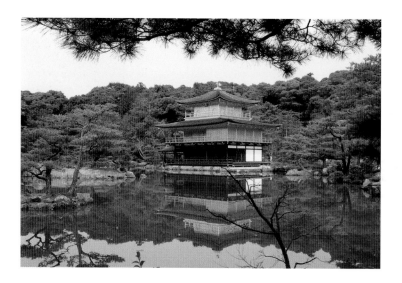

designed in a different architectural style. The first floor is built in a residential style, while the second floor is designed as a Buddha hall (housing an image of the Bodhisattva Kannon), and the third floor is in Zen style (holding Buddha's ashes).

In general, Japanese architecture is understood to be simple and understated, with a refined sense of design and use of natural materials. But here at the Golden Pavilion, the second and third floors are completely covered in gold leaf and, as a result, the building offers a startling and gorgeous image. At the same time, the composition of the pavilion precinct in particular provides a sense of balance between the sumptuous and the simple. This reminds me of how gold leaf folding screen is used in an understated room to indicate a special place.

At the foot of the Kitayama Mountains in a sea of green, the Golden Pavilion suddenly appears and its beauty is immediately apparent, making the depiction by Yukio Mishima in his novel *Temple of the Golden Pavilion* redundant. A young Buddhist priest burned down the original in 1950, being enchanted by, and yet attempting to dominate, the pavilion's beauty. The pavilion was rebuilt in 1955 as a perfect replica of the original.

40   Golden Pavilion (originally built in 1398) and its reflection on the lake.
This is the most beautiful scene of which Japan is proud. The beauty of its reflection shining on the surface of the lake, the gorgeousness of the gold-leaf-pasted structure, and its harmony with the surrounding trees—it is not difficult to explain why this scene is so beautiful. But why did it suddenly appear? This could only be explained by its sense of bipolarity.

## Golden Tea-Ceremony Room, MOA Museum, Shizuoka Prefecture 41

This is also a tea-ceremony room that was originally created by Rikyu. The restoration was carried out by leading scholars of architectural history. Built about the same time as the creation of

**41** Golden tea-ceremony room (original work by Rikyu, restored by scholars).
Why did Rikyu create this tea-ceremony room at the same time as Taian, which is highly esteemed as the ultimate in restrained and understated elegance? While the use of gold is moderate and unpolished, such an example could only be explained by bipolarity.

Taian, and the ultimate example of restrained and understated elegance, this tea-ceremony room was constructed by order of Hideyoshi. These two examples created by the same person at almost the same time clearly show the bipolar feature of the Japanese.

Before I actually saw the Golden Tea-Ceremony Room for the first time, I took it to be a dazzling fake, but I was surprised that I experienced no such impression on seeing it. Rather, I was able to feel the result of exhaustive studies in pursuit of the summit that were common to Taian. Scarlet tatami mats and paper screens were really effective, and though the tea sets looked like gold, all the other architectural fixtures did not seem to be real gold; rather, I could feel the excellence of the close study of the materials.

A court noble who attended the tea ceremony to which Hideyoshi invited the Emperor kept a diary, in which he wrote that "the walls seemed earthen not golden," which was the same impression as mine. It could be said that an uncommon nobleness hung in the air. The Japanese sense of beauty is hidden in the moderate way according to which the gold was not brilliantly polished.

### Nikko Toshogu Shrine, Tochigi Prefecture 42, 43

There is a saying that "one does not know what beauty really is until one has seen Nikko Shrine." The buildings of Nikko Toshogu, which are so brilliantly colored and richly decorated with deep relief carvings, are so beautiful yet quite different from other Japanese architecture.

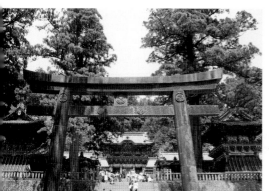
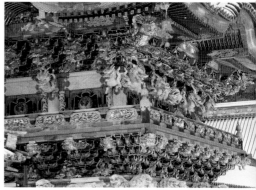

Toshogu is a Shinto shrine initially built in 1617 and dedicated to Tokugawa Ieyasu, the founder of the Tokugawa shogunate. As the mausoleum of the great Ieyasu, built in order to show the power of the Tokugawa family, it was created as a place completely different from traditional shrines and temples. Because of the extreme ornamentation and lack of restraint, structures at Nikko are often criticized as heretical in Japanese architectural history. Nevertheless, one cannot help but admire the skill and the craftsmanship they reflect.

The five structures of Toshogu are categorized as Japanese National Treasures. One of them is the photographed Yomeimon Gate, the main gate of the shrine. It bears the nickname Higurashi-no-mon, which means that one could stare at the gate until sunset and not get tired of looking at it.

### Zuihoden, Sendai, Miyagi Prefecture 44, 45

Zuihoden was the mausoleum built twenty years after the completion of Toshogu, Nikko, according to the order left by Masamune Date, the founder of Sendai Domain. It was designated as a National Treasure for its beautiful Momoyama style, but was burned down in World War II and subsequently rebuilt in the original style. Because of the power of Date, succeeding lords of the Date clan erected mausoleums in the adjacent sites, each of which were brilliantly colored. The buildings at Toshogu, Nikko, were thus not the only ones considered heretical. Such bipolar features of Japanese sensitivity can to be found where such necessity existed.

42   A scene looking up to Yomeimon Gate.
Buildings beyond this *torii* gate are built according to completely different concepts. The monumental aspects are much stronger; brilliance is more important than function.

43   Numerous carvings and multiple colors on Yomeimon Gate.
A great number of carvings, gold leaf, and brilliant colors, as are rarely found in Japan.

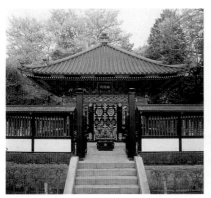
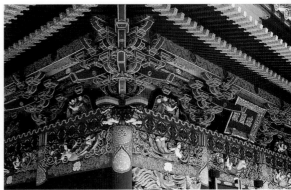

**44  Front view of Zuihoden (originally built in 1637).**
The mausoleum of the founder of the Sendai Domain was built differently from other Japanese architecture; namely, brilliance was strongly pursued and the challenge to Toshogu, Nikko should have been considered deeply.

**45  Numerous decorations similar to those on Yomeimon Gate of Toshogu, Nikko.**
This building was completely restored after being burned down in World War II. It is difficult to tell how precisely the restoration work was carried out, but the aims of the decorations are nevertheless understood.

In this chapter, I have picked examples that are gorgeous and brilliant. Thus, Japanese architecture has diverse and bipolar aspects. From "restrained and understated elegance" to "gorgeous brilliance," there exist diverse possibilities, which create the values of Japanese identities. Forms that are controlled by a total image and homogeneous modeling are likely to be hard and plain, while Japanese forms that are brought about diversely seem to be more tasteful and graceful. Diversity is naturally a necessary condition for the Japanese uniqueness that requires that "parts be put together and as a result, the best be created," to which I will refer in the following chapter.

# Spirit of
Coexistence

Without having an image of the whole, how can the whole be originated from individual parts in a cohesive way? In the background, there is a unique Japanese sensitivity. In other words, different ideas, different eras, different styles, different principles and policies can collaterally coexist, may be anything, so to speak. "Sensitivity without denial" is the starting point that permits the whole to be created as the result of the combination of various parts.

This naturally applies to the present social situation in Japan as well. "Sensitivity without denial" has a major impact on the urgent decision facing Japanese society of whether to continue to rely on nuclear power or to abandon it. A clear decision or national consensus on the choice is unlikely. Arguments will continue in Japan, while in the West, the United States and France have made it clear that they will stick with nuclear power, and Germany has declared its intention to phase out all its nuclear plants by 2020.

## Acceptance of Foreign Culture and Coexistence with Tradition

In his work "Characteristics of Japanese Architecture," Hirotaro Ota says:

> The culture of developed countries came over to Japan several times in history. Architecture, of course, is not an exception. As for the big waves, there were the architectural influences of six dynasties of China and the Tang dynasty in the Asuka/

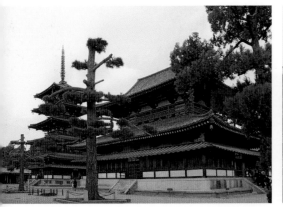
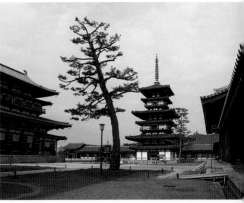

46 Horyuji Temple, the oldest wooden structure in the world, from the seventh century.

47 Yakushiji Temple, after restoration work.

Nara period, the introduction of Song-dynasty style in the Kamakura period, and the import of Western civilization after the Meiji Restoration. Owing to the fact that Japan is isolated from the continent, Japanese people have not been politically controlled by the continent. Therefore, the Japanese were accustomed to accepting different cultures in a peaceful manner, and it was possible to import foreign culture without falling into ethnic bigotry. (Ota 1954)

An overall view of the Buddhist architecture imported in the Asuka/Nara period can be seen at Horyuji Temple and the restored Yakushiji Temple. 46, 47

This Buddhist architecture was completely different from the original Japanese architecture in style, construction method, and the colors used. Buddhism itself was not accepted without any resistance at the beginning. Even in the Imperial Court, there were arguments for and against it. But before long, Buddhism became a major force and spread across Japan. In addition, it influenced the architecture of many temples. When Prince Shotoku—who was deeply devoted to Buddhism—held power, it is said that over forty temples were built, including Horyuji Temple. However, that does not mean that Buddhist architecture replaced traditional Japanese architecture. Rather, both styles fully coexisted, as can be seen in the long history of Japanese architecture.

On the introduction of Song-dynasty style in the Kamakura period, the influence of which can be found in the Zen temples of Kamakura and other places, Ota says:

It is still not evident whether it was a complete copy or whether it was a result of selection. But the ethnic culture of the Japanese that developed within the natural and social conditions as described above was quite different in quality from that of the continent, and therefore, it should have been impossible to copy everything completely.

There was an essential difference between the magnificent exaggerated expressions of the continent and the intensive refined expressions of the Japanese, and even if the will to choose deliberately did not work, it should have resulted in the unconscious choice of selecting only what they liked. (Ota 1954)

In any case, Song-dynasty style was not accepted as it was on the continent.

The characteristics that were said to be the distinctive features of Japanese architecture had great impacts on them, and through Japanization both styles were able to coexist. In other words, through combination with Japanese characteristics such as "intimacy with nature," "insistency on materials," and "simplicity of design," these features became Soong style in Japan. 48, 49

As for Kenchoji Temple, which is a representative example of Soong style, although all the original buildings have been lost, it is said that the image of the temple in its founding days remains in the layout of the precinct in which the outer gate, Sam-mon gate, the Buddhist hall, the lecture hall, and the priest's quarters were built in a straight line

48, 49  Sam-mon gate, Kenchoji Temple, Kamakura, Kanagawa Prefecture (originally completed in 1253). Characteristics of Soong style such as the bend of the roof, brackets between pillars, and structural penetrating tie beams can be found, but they are not a complete imitation. In order to be more comfortable with Japanese sensitivity, elements of Japanization, such as a gentler bend of the roof, have been introduced, and the Soong style has likely been absorbed into Japanese society without any resistance.

The import of Western civilization in the Meiji period was accepted by the Japanese with a culture-shock-like surprise as they faced the advanced civilization that had developed through the Industrial Revolution and that would have a great impact on how the Japanese way of life changed. Architecture, of course, was not an exception and was completely overwhelmed by new designs, new materials, and new methods of construction. But even in such circumstances, the characteristics of Japanese architecture survived and, recently, their wonders are being recognized again. This goes to the heart of my assertion in this book that Japanese identities ceaselessly breathe.

## Japanese Faith Pushes Coexistence from Behind

Needless to say, the myriads of gods in which the Japanese believe have a great influence upon the collateral coexisting features of Japanese architecture. In ancient Japan, mainly through worship of the natural world, each tribe believed in its peculiar god individually. These individual gods became related to Shinto gods, while Buddhism and other religions were accepted later. There is little doubt that the coexistence of these gods is one of the origins of Japanese sensitivity.

By contrast, under one absolute god as in Christianity and Islam, neither compromise nor coexistence is accepted. Even in the world of architecture, it is well known that a cycle of destruction and construction continued according to the changing of rule of one god or another.

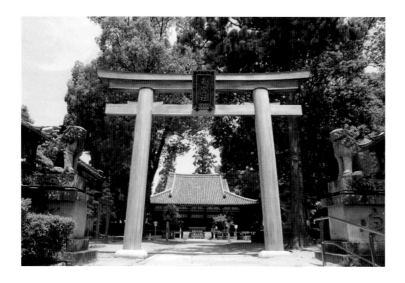

Meanwhile, the syncretism of Shinto and Buddhism that led to the unification of the two religions is very distinctive. Examples of a temple within a shrine precinct or a shrine attached to a temple are found all over the country. Here is one representative example: 50

The fact that the objects of religious belief that are linked directly to daily lives are diverse will have great influence on the Japanese sense of values and criteria for making judgments. No absolute code exists for determining how one must behave, and therefore, diverse possibilities collaterally coexist. The mentality of the Japanese that enables various parts to collaterally coexist is quite convenient for establishing the creative process that the whole is created from parts.

### Shin-Gyo-So

Heibonsha's *World Encyclopedia* (second edition) explains *shin-gyo-so*, which may be mentioned as one of the concepts expressing the characteristics of Japanese culture, as follows:

> The words indicate the types of style of calligraphy. Furthermore, they have been widely used to express the sense of beauty of the Japanese. Wang Xizhi, a Chinese calligrapher who lived during the Jin dynasty (265–420), created the base of calligraphy and also three styles were said to be established by him, namely, *shin* (formal), *gyo* (semiformal), and *so* (informal). In Japan, the letter *shin-gyo-so* by Wang Xizhi was found on the "Shosoin lists of articles," which was from the

50  Example of a shrine-attached temple, Sakurai, Nara.
Syncretism was practiced from the Nara period at Omiwajinnja Shrine, which is said to be one of the oldest shrines in Japan. The photograph shows Waka-miya Shrine, which was a shrine attached temple called Daigorinji Temple until the Meiji period. The God of Wakamiya and the eleven-faced Goddess of Mercy were enshrined together. (Article: Asahi Shinbun Digital)

second half of the Nara period. Along with the spread of calligraphy, *shin-gyo-so* came to be used as a term to represent three stages of style not only in calligraphy but also in various genres—*shin* for most prestigious and formal, *gyo* for intermediate, and *so* for the most exceptional at the other end of the spectrum.

It is thus possible to understand what is generally meant by *shin-gyo-so*, and here we quote explanations of tea-ceremony tools from the Omotesenke tea-ceremony school website. These refer to *shin-gyo-so*, relate to the architectural world, and also are easy to understand.

In the world of the tea ceremony, *shin-gyo-so* are often used. These words refer to three types of style in calligraphy: *shin* is the original form, *gyo* is the slightly simplified form, and *so* is written in running style. These three types of style were applied to the world of the tea ceremony and classified its styles as *shin-gyo-so*.

To give an example explaining tea-ceremony tools, the utensil-stand and the set of tea-tools that came from China and that were used when serving noble people such as General Ashikaga or gods and Buddha are ranked *shin*. In contrast to those Chinese tools, domestic ceramics that expressed the charm of soil and simple tools utilizing materials such as bamboos and trees are ranked so. And the intermediate form, for example, domestic ceramics that resembled Chinese chinaware are ranked *gyo*. There are distinctions of *shin-gyo-so* among

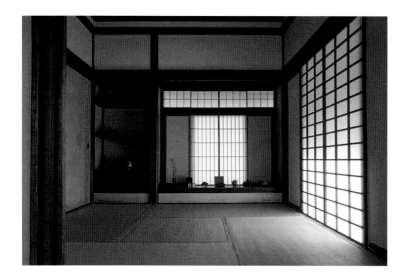

not only pottery but all other tools and tea-ceremony rooms. Although it may give a stiff impression to look at *shin-gyo-so* as a determined promise, in fact, the Japanese way of accepting foreign culture is seen in this classification. From those things that were Japanized by breaking from their original forms and whose changes, through decisive simplification, disguised themselves as different things from original figures, it is interesting to know not only the development from Chinese tools to Japanese tools but also how to understand Japanese culture, namely, *shin-gyo-so* from the viewpoint of "to imitate, to put in disorder, to disguise."

When we look at things in this way, it is understood that *shin-gyo-so* is a concept that can help us uniformly comprehend different styles and forms. In his work *Thoughts in Japanese Design*, Teiji Ito says:

> The people often say that our culture was familiar with neither negation nor conquest. Once architecture, gardens, industrial arts, and even entertainment were born, their styles continued to exist without being destroyed. ... If the new style was born as the result of negation and conquest of the old style, it is natural that the old style should be forgotten in the new era. ... The history and the characteristics of our culture, in the design field, were expressed in the form of *shin-gyo-so*. (Ito 1966)

It is possible to organize various different styles by *shin-gyo-so* and to justify the presence of each style, and it can be said that

51  Dojinsai study room, Togudo, Jishoji Temple (Silver Pavilion), Kyoto. *Shin*: Formal form based on the samurai lifestyle, so neat and rigid.

52  Middle garden
guest house, Shugakuin
Imperial Villa, Kyoto.
*Gyo*: A playful mind is
strongly reflected in the
staggered shelves, wall
design, and sliding screen
paintings.

53  Jo-an Tearoom,
Aichi Prefecture
*So*: Keen-edged space with
minimum components.

*shin-gyo-so* has promoted the coexistence and collateral of various styles and forms. But it is more correct to say it has prompted the sense that it is natural to have three styles/three states for anything. The fact is that such a value system has become widely rooted in Japanese culture, and that the formation of collateral coexisting culture without negation are both sides of the same coin.

*Shin-gyo-so* is a very useful concept that makes it possible to justify the existence of various styles in general by just using the term when there are various architectural styles and forms in Japan. For example, among existing *shoin* architecture, which developed in the lifestyle of samurai, Dojinsai, a study room of Togudo Hall, Jishoji Temple, which is said to be the origin of that architectural style, is ranked *shin*; *shoin* architecture in the *sukiya* style that avoided the stiff atmosphere of samurai life is classified as *gyo*; and the ultimate thatched hut used as a tea-ceremony room can be ranked so. Thus, any coexisting style can be explained by this *shin-gyo-so*. 51, 52, 53

From ancient times, when the objects of religious belief that were linked directly to daily life were diverse and there was no absolute code for determining how one must behave, "sensitivity without denial" or the "mentality that anything goes" was cultivated. This mentality of the Japanese accepted foreign culture without resistance and created the way for justifying the collateral coexistence of diverse possibilities. It can be said that this developed the grounds for the parts to assert themselves freely.

# CHARACTERISTICS OF JAPANESE ARCHITECTURAL COMPOSITION

# Asymmetry

In an agrarian society, so the Japanese believe, one does not conquer nature but rather fears and respects nature and walks together with it. And nature has no fixed form but rather a free form that is ever changing. In the creative activity of those Japanese who tried to work with nature, it was inevitable that the free form originating from nature would come to occupy a major position. It can be said that the artificial geometric form and the static symmetrical form were the opposing poles of Japanese sensitivity.

In addition, in the world of flower arrangement that had a major impact on medieval design, emphasis was placed on the asymmetrical harmony of elements. Guided by dynamic balance within asymmetry, the Japanese can be said to have actively pursued this quality. The pursuit of symmetrical beauty as in the Western world was difficult, in any case, because the form of materials for flower arrangement was irregular and not perfect.

Symmetry is the product of a master plan and asymmetry naturally occurs as the result of a process of composition that looks at the whole from its parts. Homogeneity is also produced by the precedence of the total image and results from logic as a whole regulating its parts. The emphasis on axis and symmetry found in Western urban planning and garden planning strongly regulates not only the placement and the form of individual parts but also the ways they exist, and those plans result in a strong homogeneity under overall control. In the Japanese creation process, by contrast, in which parts precede the whole, the flexibility of

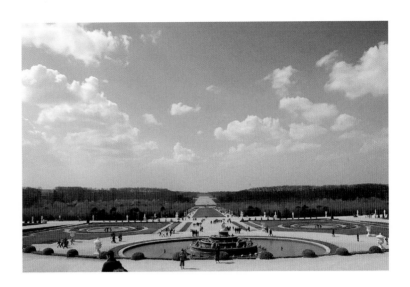

54 **The garden of the Château de Versailles, France.**

Standing on the terrace of the Versailles Palace, one will notice the existence of an absolute axis. This is an assertion of human creation. All parts of the garden are regulated by the axis and, as a result, an orderly symmetry is firmly maintained.

each part appears in the organic, nonhomogeneous character of the whole. 54

In Western garden planning, and particularly in French gardens, the absolute axis of the whole layout, including buildings, is of the greatest importance, and there is a strong requirement to emphasize this axis. This axis is paramount in the vast garden of the Château de Versailles, and as a result, the garden deliberately acknowledges the symmetry of the whole. This strong axis not only penetrates the garden and buildings: the walkways, ponds, monuments, and art objects are all placed on the axis, and the layout design is in a homogenous context. This kind of emphasis on an axis dominated subsequent urban planning in Paris. The absolute axis of Paris starts from the Elysees Palace to the Place de la Concorde and the Arc de Triomphe, leading further to the new Arc de Triomphe of Defense.

Most of the intentional architecture is made by way of descending from the whole to the parts. This type of design considers the conditions given initially, makes the most suitable overall pattern from these conditions, and descends from this pattern to the parts again. ... Of course, the overall design, along with the work revised by the partial study, will be repeated downward (division) and upward (composition). However, giving an overall pattern in the early stage will probably produce formal architecture.

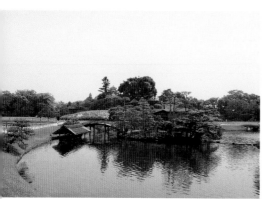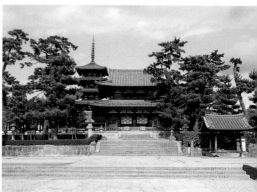

This is what Hiroshi Hara says in his work *What Is Possible through Architecture*, which is vividly shown in the case of Versailles Palace (Hara 1970).

By contrast, the Japanese garden is merely a reproduction of a natural landscape; therefore, organic asymmetry is dominant. Beyond pursuing natural form, it cannot become artificially symmetrical. 55

Korakuen Garden, which was constructed by order of the Okayama feudal lord and completed in 1700 after fourteen years of construction, is regarded as one of the three most beautiful gardens in Japan, along with Kenrokuen and Kairakuen. It was designed so as to take in the flow of the Asahi River in the *kaiyu* (strolling) style, which presents visitors with a new view at every turn of the path connecting the vast lawns, ponds, hills, teahouses, and streams. The magnificent views of ponds and hills can also be enjoyed from the teahouses, which were built for each succeeding daimyo and are located throughout the garden. Okayama Castle and the surrounding mountains in the background are nice examples of borrowed scenery.

### Horyuji Temple, Nara 56, 57

Horyuji was built in 607 by Crown Prince Shotoku and was one of the most dignified temples at that time. According to historical documents, Horyuji was completely destroyed by a great fire in 670, but was rebuilt soon after.

55 Korakuen Garden, Okayama (completed in 1700).
Although this is the epitome of a natural landscape, it is an artificial garden, with every part designed in detail. The flexibility of each part is highly respected; therefore, it cannot become symmetrical.

56 Inner gate and Saiin precinct.
The Pagoda on the left and Main Hall on the right of the central axis. This main approach shows the delicate balance in the layout, including the trees, through which the Japanese feel more natural.

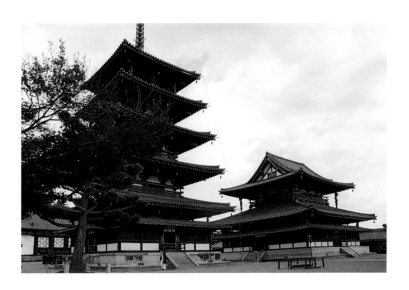

Notice the asymmetrical disposition of the Main Hall (on the right) and the Pagoda (on the left) in the precincts surrounded by the corridor. Under the strong influence of the relative culture of the continent, the layout of the temple architecture at that time was completely symmetrical without exception, but here the builders dared to ignore symmetry. Asymmetry is one of the important keywords for understanding the Japanese aesthetic sense.

### Izumo Taisha Shrine, Shimane 58, 59, 60

The origins of the Izumo Taisha buildings date back as far as the mid-seventh century, with the architectural style of the Main Hall being one of the three prototypes of ancient shrine architecture. According to tradition, the hall was previously twice as high, and the recent discovery of the remains of enormous pillars might give credence to this belief. The present hall was rebuilt in a much smaller size in 1744, although the original architectural style was emphatically preserved.

It is interesting to note that the buildings are slightly misaligned. This creates a somewhat informal atmosphere along with the feeling of greater depth in the given area.

Shinto architecture also seems to have been under the influence of the strong culture of relativity from the continent, but these unique Japanese configurations of space and building layouts were given priority.

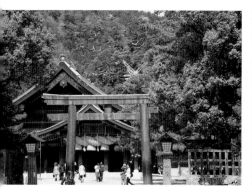
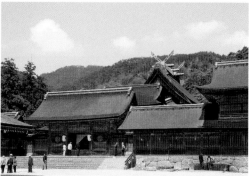

## Kyoto Imperial Palace, Kyoto

Kyoto Imperial Palace is one of the most typical and representative architectural constructions in Japan. The current Kyoto Imperial Palace used to be one of the temporary palaces that had been built outside the original Heian Palace. It had been the Imperial Palace from 1331 to 1869, when the capital was moved to Tokyo. During this period, there were repeated instances of fire and reconstruction; extensions were also built, adding new functions.

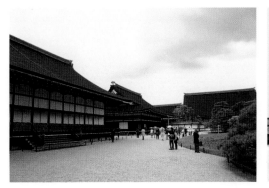
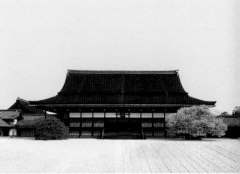

**61 Kogosho, Ogakumonjo, Otsunegoten (from left).**
The placement of each building is likely determined spontaneously. There seems to be no intention to regulate the placement and form of each building from the overall image of the palace. Rather, the relationship between the buildings and exterior spaces is of great importance. As a result, asymmetry is inevitable.

**62 Shishinden (Hall of State Ceremonies).**
The neglecting of symmetry by planting.

From Shishinden (Hall of State Ceremonies) to Otsunegoten and beyond to the Chosetsu Teahouse via Kogosho and Ogakumonjo, extensions continued northward. The buildings were added by crossing their ridges at right angles and by adding connecting corridors. What was considered important were the relationships between added buildings, the grand Oikeniwa Garden, and other exterior spaces. The layout of the extensions was determined spontaneously, which differs significantly from the strong assertion of symmetry that is found in the West, at the Chateau de Versailles or the Schönbrunn Palace of Vienna. 61

This is the front face of Shishinden, which is the most formal face of the Kyoto Imperial Palace. The building was built symmetrically to conform to an ancient rite but, as if to eliminate this symmetry, a pair of trees were planted—a *tachibana* tree on the right and a cherry tree on the left. Although these trees were planted in accordance with the ancient rite and the origin of this planting has also been communicated through time, morphologically it is clear that there was an intention to eliminate the tension of symmetry. It is said that the cherry tree was at first a plum tree, but in any case, an evergreen tree and a deciduous tree were paired to display asymmetry. 62

Since the introduction of *jori-sei* (the ancient Japanese system of land subdivision), there have been attempts in our country to fix the symmetrical order numerous times, but it is likely that on each occasion there was some influence to exclude symmetry. Here, one of the origins of this power is acknowledged.

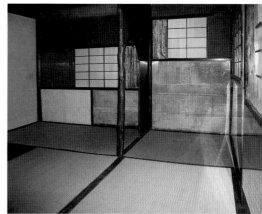

### Jo-an Teahouse, Aichi 63, 64

In the ultimate small space—namely, the tearoom—manners and features are the top priority, and one function of the scarce margin of space is to reinforce the room's shape and formality. The crawl-through doorway from the dirt floor, the seat for guests and the alcove, the furnace and the seat for the host—all of these are arranged according to functional necessity; a symmetrical arrangement is out of the question. The exterior appearance also directly represents functions and is thus inevitably asymmetric. The façade of Jo-an, delicately balanced while asymmetrical, is very tasteful.

As for the creative activities of those Japanese who try to maintain a good relationship with nature, it is logical that they pursue free forms related to the natural environment.

When the concept of the temple complex was first imported from mainland China, everything was positioned symmetrically, but soon after, Japanese people avoided this uniform layout as seen at Horyuji, the oldest remaining temple. Most Japanese architectural styles were based on daily activities rather than monuments; hence the symmetrical style did not develop. In other words, the Japanese process of creation starting from the parts did not allow for symmetrical creation. The asymmetrical approach is most notably seen in interior design and fittings for residential use.

By contrast, Shuichi Kato, in his work *Time and Space of Japanese Culture*, describes the origins of the pursuit of asymmetry by the Japanese as follows: "Parts precede the whole. Details are

63 Façade without regulating order (said to have been built in 1618 on its original site in Kyoto).
Entrance, eaves, windows, etc.—everything is where it is needed. Form is a mere result of necessity.

64 Placement of windows, the first priorities of which are lighting and vista effect.
In the condensed small space, the intention to adjust shape and placement does not work. Function and effect are the first priority; everything is determined by the functional movements of the host and the customer. There is no scope for symmetry.

independent from the whole and assert their own, proper form and function. This is the worldview behind asymmetrical aesthetics" (Kato 2007).

Symmetry is the product of the overall design, and in the process leading to the whole from the detail, there is likely to be no place for it.

# Culture of Addition

**Addition (Katsura Imperial Villa, Kyoto)** 65, 66

The culture of "formative development from parts to the whole" is in a sense the "culture of addition" (Ito 1996). From investigations undertaken during dismantling and repair work at the Katsura Imperial Villa in Kyoto, it was found that a series of buildings ranging from Old Shoin and Middle Shoin to the New Palace had been added. 67

By orthogonally connecting these buildings, it was possible to create a rich relationship with the garden and realize a segmentation of the function of the space to create a more private New Palace. As for Japanese culture, the evolution of creativity does not necessarily mean that the old is denied and replaced with the new. It is possible to enable coexistence with the old by adding the new. The total composition of the buildings of Katsura Imperial Villa is a perfect example of the result of the addition of parts, which are Old Shoin, Middle Shoin, and the New Palace.

**Orthogonal Design/Flying Geese Pattern (Nijo Castle, Kyoto)**

Ninomaru Palace in Nijo Castle was built almost at the same time as Katsura Imperial Villa but differed because all of its buildings were constructed simultaneously, each with its own function. The palace is the result of the addition of functions. 68

In Japanese architecture, huge roofs are avoided by keeping the gradient. Large buildings in terms of depth are not built and extensions are made by orthogonally connecting separate buildings

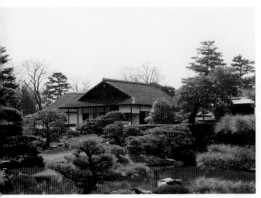

65 Old Shoin.

66 New Palace, Musical Instrument Room, Middle Shoin (from left).

67 Plan of main buildings of Katsura Imperial Villa (constructed over several decades after 1615).

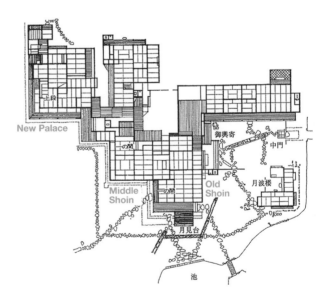

New Palace

御輿寄

中門

月波楼

Old Shoin

Middle Shoin

月見台

池

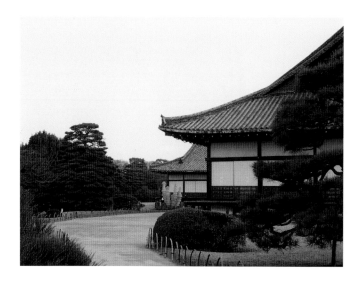

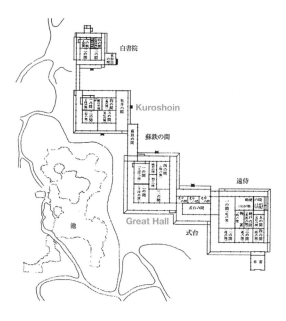

白書院

Kuroshoin

蘇鉄の間

遠侍

Great Hall

式台

池

68 Ninomaru Palace in Nijo Castle (completed in 1626).
(back): Kuroshoin (Inner Audience Chamber), (front): Ohiroma (Great Hall). Big hip-and-gable roofs are connected orthogonally. Small spaces with respective functions are added, and the inside has a strong hierarchy of space.

69 Plan of Ninomaru Palace, Nijo Castle.

with a corridor. Moreover, in order to maintain the most open and continuous relationship possible with the garden, without placing ridges in a straight line, buildings are connected in the flying geese pattern.

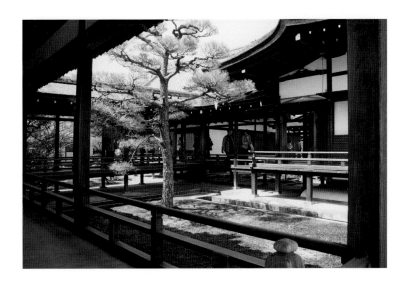

70   Ninnaji Temple,
Kyoto.
Connecting corridors be-
came essential for adding
separate buildings. They are
the symbol of the culture of
extension.

This is very effective for the segmentation of large-scale buildings
in terms of adjusting the sense of scale as seen from the garden. At
Ninomaru Palace, Tozamurai, Shikidai, Ohiroma, Sotetsunoma,
Kuroshoin, and Shiroshoin were placed in a flying geese pattern
and were internally connected by a corridor that turns orthogo-
nally, thus creating an extremely strong hierarchy of space. Each
time the corridor makes a turn, it prompts a recognition that
you are entering the next zone. From the front toward the space
further inside, from the waiting room of feudal generals to the
audience chamber of the Tokugawa shogun, subsequently more
prestigious rooms are placed as one proceeds. And at the end, the
corridor connects to a more private zone for the shogun. Such a
flying geese pattern is completely different from the output of
configuration created by dividing the whole. This is the result
of addition, making the morphological completeness as a whole
weak, while further extension remains possible, meaning that the
total picture would inevitably become asymmetrical. 69

### Technique of Connection (Ninnaji Temple, Kyoto) 70
In order to practice addition, it is necessary to develop techniques
or methods to connect various parts. As for Japanese architec-
ture from ancient times, the fact that small buildings (which had
been connected according to need) were used rather than large
buildings (which had been divided into necessary parts) is clearly
seen in the layout of temples and shrines. "It can be said that
the part of a building that connects separate buildings developed

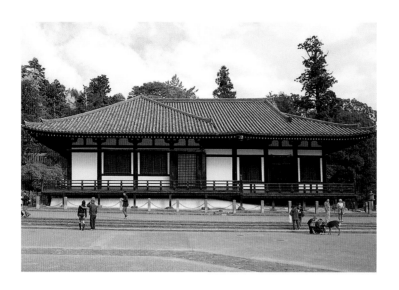

71  Sangatsudo Hall,
Todaiji Temple.
The right half of the build-
ing was added to the left
half 500 years after it was
constructed. A gable-and-
hip roof was added to a
hipped roof, as the result of
the culture of addition. This
is a world where anything
goes without care for form
or style.

72  Section of
Sangatsudo Hall, Todaiji
Temple.
From the section drawing,
it can clearly be seen that
the worship hall (from the
right side) was added to the
main hall (on left side).

historically, showing different methods—such as exposed corri-
dors, roofed corridors, or intervention of a connecting room—in
order to become an internal space, or to connect directly" (Kawa-
michi 2001).

At Itsukushima Jinja, connecting passages have developed to be-
come admirable corridors, which are now the main character in
the total configuration. By contrast, at Katsura Imperial Villa (as
shown above), the Musical Instrument Room, which connects
Middle Shoin and the New Palace, is a good example of a space
that developed to be completely internal.

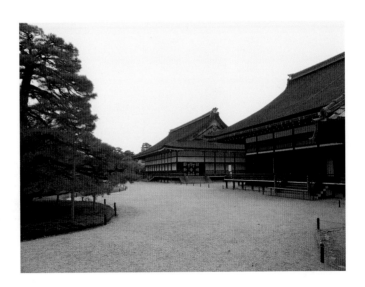

73 Oikeniwa, Kyoto Imperial Palace. Ogakumonjo (study hall) in the front and Kogosho in the back. These buildings show a blend of old architectural elements of the Heian period. They were built in accordance with the necessity of function, and extension work was carried out in graceful manner.

## Unification (Todaiji, Nara) 71

Sangatsudo Hall of Todaiji Temple, which is designated as a National Treasure, is one of the few buildings dating back to the Nara period and is as old as the construction of Great Buddha Hall. But only four intervals (between posts) to the left of the photo are from the Nara period, and they are the main part of the building where the principal image is enshrined. Four intervals to the right were extended in the Kamakura period as a worship hall, and the difference in style of each period can be seen in the architectural joints atop the posts.

It is understood that the main hall section is in the hipped-roof style and the worship hall section is in the gable-and-hip style. But the point is that, without reconstructing the whole building in the first place, the extension of the building, which was already 500 years old, is a strong reflection of the "culture of addition." And what is worth our attention is the fact that the unification of these old and new buildings, despite the delicate differences in architectural joints and heights of beams, results in a powerful harmony beyond architectural styles. This is a proof of the Japanese characteristic that, together with the principle of "parts precede the whole," it is as a whole that the best possible total is created. 72

## Extension (Kyoto Imperial Palace) 73

The buildings and the landscape of Kyoto Imperial Palace invite visitors to experience an elegant perception of space that is unique to Japan. In this relaxing atmosphere, it seems that time passes

more slowly and differently than in contemporary Japan. We will now look at the spatial structure of this palace. 74

74  Site plan of Kyoto Imperial Palace.

The groups of architecture at Kyoto Imperial Palace clearly show that Japanese culture is recognizable as the "culture of addition." Shishinden (the most prestigious hall for state ceremonies) and Seiryoden (the pavilion used as the Emperor's normal residence), both of which are built in the manner of Heian period palatial architecture (*shinden-zukuri* style), as well as Kogosho (the small palatial hall) and Ogakumonjo (the study hall), which are built in a mixed palatial and residential style (*shoin-zukuri* style), have been added together and further connected to several buildings: a more private Otsunegoten (living quarters for the Emperor, the interior of which was completely built in a residential style and partly in *sukiya* style), Koushun (study room), Oshuzumisho (cool-down space), and the Chousetsu Tearoom.

These palatial halls and attached buildings are organically connected by hallways and corridors, thus creating inner courts with white sand and spot gardens, and a spacious garden with a large

88

pond has been placed in the middle. The buildings are basically constructed in the graceful *shinden-zukuri* style, but the transition to the *shoin-zukuri* style and further to the *sukiya* style can be seen, and buildings have clearly been added from time to time. Until now, there has been a cycle of fire disasters and reconstruction, and the main palace buildings have been restored to the ancient Heian period style according to documentation. (The current buildings were mainly reconstructed in 1855.)

It is obvious that the architecture of Kyoto Imperial Palace is the aggregate of individual palace buildings. Yet as a whole, it has the graceful atmosphere of the dynasty culture of the Heian period, which is simple but elegant and refined.

When one looks at the overall plan of Kyoto Imperial Palace, it is obvious that the buildings were constructed sequentially. At each part, the form was determined to satisfy the functional needs. But as the whole, the configuration was left to chance. These buildings were nevertheless not just mere additions. An appropriate sense of scale, a harmonious relationship with the garden, and the sense of *oku* were realized, and the graceful atmosphere of the dynasty culture of the Heian period and the refined architectural style of early modern times were incorporated. The "culture of addition" embodies the "parts-precede-the-whole" Japanese creation process, expresses diverse Japanese architectural characteristics, and realizes the rich Japanese environment.

# Devotion to Small Space

As mentioned above, Shuichi Kato pointed out that "the culture whose interest in the whole was weak produced, at the same time, a strong interest in the parts" (Kato 2007). The parts-precede-the-whole creation process intensively focuses on parts.

Furthermore, from the perspective of "now = here," what is in front of the eyes becomes the top priority and will inevitably concentrate the interest of those who are looking. Therefore, the characteristic of Japanese creation that "the whole would be created from the parts" is directly linked to the approach that creative energy is concentrated in the small space in front of the eyes.

## Taian Tearoom, Myokian Temple, Kyoto

The combination of *wabi* and *sabi* is said to be one of the most distinctive characteristics of the Japanese sense of beauty. One could refer to many sources for an explanation of these terms, but I explain them as follows: *wabi* connotes rustic simplicity and understated elegance, while *sabi* is beauty or serenity that comes with age or solitude.

When applied to architecture, what distinctive features does this bring about? It may be said that the use of natural materials as they are—without processing or painting, or in a quiet and distinctive atmosphere—allows an inner beauty to emerge from architecture's simple appearance. And in the background of such creation, there is a glimpse of an abstract sense of value.

This Taian Tearoom by Senno Rikyu is a representative structure

75  Taian Tearoom, a
National Treasure (said
to have been built during
Battle of Yamazaki in
1582).
Ideas for the ceiling,
placement of windows for
lighting, configuration of the
alcove, study of the mate-
rials, details for finishing,
etc.—the energy of creation
is concentrated in this
minimal space. As a result,
a rich space unaware of its
size is created.

created by the combination of the spirituality of *wabi* and *sabi*
and the devotion of energy to small spaces. 75

The Taian Tearoom, designated as a National Treasure, is the old-
est teahouse in Japan and is said to be the only remaining teahouse
known without doubt to be created by Senno Rikyu. While the
tea-ceremony room is only two mats, the entire teahouse space—
including the service room and the room next door—consists of
only four and a half mats. Why did Rikyu create such a small
tearoom with only two mats? It is conceivable that Hideyoshi
invited Rikyu to the camp ahead of the battle at Yamazaki, and
that because of the camp this space was made so small. But, first
and foremost, *wabi* and *sabi* correspond to a world of conception
and abstraction, for which a wide space is unnecessary.

It is said that Urakusai Oda, who created the Jo-an Tearoom, a
National Treasure, said: "Only two tatami would torture people."
But when I visited the site, I didn't have the impression at all
that the space was too small. It only consists of two mats and an
alcove, but the ceiling height is enough for the small area, and
the existence of a sloping ceiling is very effective. The interior is
full of rich light from windows that are opened, giving priority
to the best lighting. Because plaster has been applied around the
corner walls of the fireplace, one is not aware of the corner and a
widened effect is created. The depth of the alcove is enough for
its frontage, and it contributes greatly to the three-dimensional
effect of the interior space together with the variation of the ceil-
ing. The chief priest told me that the back wall of the alcove was

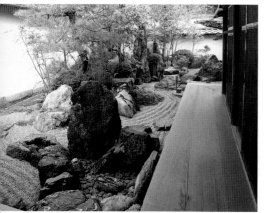

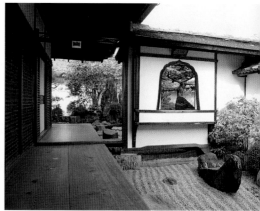

(1)

(2)

plastered top to bottom into an approximately two-centimeter concave form, thus creating the appearance of depth.

The simple and sophisticated space that is configured merely by plastering the wall with straw on the surface, the multiple use of local bamboos, the rough finishing leaving marks of the adze on the alcove post, and the feelings and colors of natural materials tells us about the basis of *wabi* and *sabi*. What is enclosed in this minimal space and the resulting rise of refined spiritual energy are extreme examples of Japanese identities.

### Rock Garden, Daisen-in, Daitokuji Temple, Kyoto 76, 77, 79

This is a representative dry landscape from the Muromachi period (1336–1573), in which various scenes are elaborated in small spaces around the abbot's quarters. There is a waterfall from Horaisan Mountain falling into the north side of the abbot's quarters, and water flows out from that place as if a dam had broken. The landscape expresses all states flowing into the ocean through the sand, and a treasure boat, crane, and tortoise through the arrangement of the garden rocks. There is an open corridor surrounding the abbot's quarters that generates a strong sense of unity in the garden and the interior of the quarters. It is created so that you can sit in the tatami room or on the open corridor to appreciate the garden. Certainly, it can be said that this is a representative space showing the devotion to small space, in which magnificent thoughts are incorporated into the small space in front of your eyes. 78

76   Mt. Horaisan (north side).
photo (1)

77   Water flow and treasure boat (east side).
photo (2)

③

**78   Great ocean (south side).**
This rock garden is often compared to that of Ryoanji Temple. This scene is the end of the magnificent story of the water flow, and what does one contemplate when looking at the great ocean and two peaks?
photo ③

**79   Abbot's quarters (completed in 1513) and rock garden, Daisen-in, Daitokuji Temple.**

On the south side of the abbot's quarters lies the spacious ocean. The expanse of dazzling white sand stimulates one's sensitivity and encourages one to let the mind wander. The previously rugged rocks all disappear, and there are only two peaks of pure and innocent white sand. The rocks are said to express human desire, and the peaks of white sand are said to represent the process of desire's purification. When one gazes at the scene and closes one's eyes, a magnificent space is felt and heartfelt thoughts fill the mind.

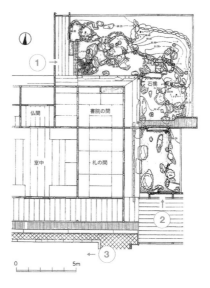

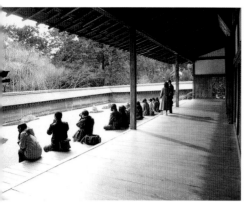

## Rock Garden, Ryoanji Temple, Kyoto 80, 81

This is the world-famous Rock Garden of Ryoanji Temple. This simple yet remarkable garden measures only twenty-five meters by ten meters but is meant to represent the whole universe. The rectangular Zen garden is completely different from other gorgeous gardens constructed in the Middle Ages. Neither trees nor water are used; the garden consists of only fifteen rocks and white gravel. But behind the configuration breathe the deep thoughts of Zen Buddhism.

Visitors sit on the veranda facing the garden to gaze at it. It is for the visitors to decide what and how they think of this abstract garden. The longer one looks at it, the more varied one's imaginations will probably become. The white gravel is often compared to the sea and the rocks to islands. But I see them as a sea of clouds and protruding peaks. It is often explained that there are fifteen rocks in the garden. But regardless of where one sits, it is impossible to see all fifteen at one glance, which signifies the imperfect nature of humankind.

The low earthen wall surrounding the garden is also of great importance. It is made of clay boiled in oil, from which the color seeps out and leads to a peculiar design over the course of time. Also, an intentional perspective effect was created by decreasing the height of the wall toward the distant corner. The garden is said to have been created by multitalented Soami, who died in 1525, but no one is quite sure. There are many opinions as to the creator and the creative intention of the garden.

80 Everyone stares at the garden (said to have been built in the late fifteenth century).
Sitting on the veranda, everyone gazes at the garden. Recently, there are more visitors from foreign countries due to the worldwide Zen boom. A Japanese rock garden, where water is expressed without its being used, hides symbolic meanings in this small space.

81 The surrounding earthen wall.
The presence of this tasteful earthen wall, which regulates the small space, contributes greatly to the formality and the sense of existence of the garden.

**94**

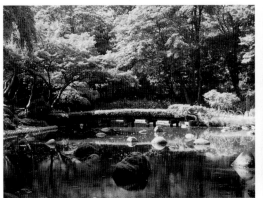
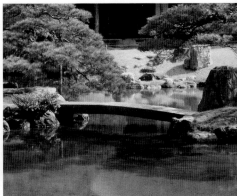

### *Shukukei* (an artificial scene constructed in a garden, which mimicked a famous natural scene) in the Gardens 82

Koishikawa Korakuen Garden is a strolling type of garden begun in 1629 by Yorifusa Tokugawa, first feudal lord of the Mito Tokugawa family, and finished by his son, Mitsukuni Tokugawa, as a garden attached to the residence, and the names of places of beauty from across the country are used here and there. The photograph is of famous scenery in Kyoto: the Katsuragawa River and Togetsukyo Bridge in Arashiyama; and it is possible to imagine that this setting was created according to the cherished memory of this Kyoto scene and with a strong yearning for it.

In this case, a hint or a motive from natural scenery creates a configuration incorporating the essential qualities of a scene into the garden, which is called *shukukei*. Here, numerous *shukukei* elements are scattered through the garden, the aggregation of which constitutes the whole. Here we can also clearly see the characteristic quality of the Japanese way of configuration that is devoted to the parts, and in which parts precede the whole.

The next example is a *shukukei* in the Katsura Imperial Villa, Kyoto. On the way to one of the teahouses, Shokintei (known as Pine-Lute Pavillion), one has a view of Amanohashidate (a natural sandbar known as one of the three most beautiful spots in Japan). It is said that this setting is associated with the scenic beauty of Tango, the birthplace of the princess of Prince Tomohito, who created this villa. The garden of the Katsura Imperial

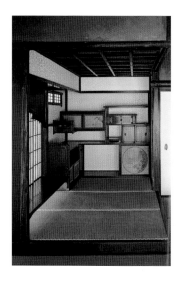

Villa can also be said to consist of a combination of various motives that it contains, and the energy that is devoted to each one of the parts is enormous. 83

## Katsura Shelves, Upper Alcove of Main Room, New Palace
## Katsura Imperial Villa, Kyoto 84

Old Shoin, Middle Shoin, and New Palace were subsequently constructed at the Katsura Imperial Villa, and it is said that *sukiya*-style designs were added over time. In the upper alcove of the main room of the New Palace, a study and shelves were attached to just a three-mat space like house fixtures, which were simply the fruits of creative energy. The details regarding their practical use, the closely examined materials, and the expression of a sense of fun are all excellent. It is inferred that the black-and-white painting on the small sliding doors is likely the work of a famous painter. These shelves are called the Katsura Shelves, which are said to be among the most distinguished shelves in Japan, together with the Mist Shelves of the guesthouse of the Shugakuin Imperial Villa and the Daigo Shelves of the Sanpo-in, Daigoji Temple.

Most importantly, even to speak of these shelves as being among the three most distinguished sets of shelves in Japan is evidence of an approach that devotes enormous energy to small parts.

84  Katsura Shelves, Upper Alcove of Main Room, New Palace. The design, materials, details, and the sense of fun help one to grasp the extraordinary creative energy that is poured into these shelves. They are said to be one of the three most distinguished groups of shelves in Japan, and this refers to the fact that the Japanese pay much attention to such small parts of a building.

Looking at these examples, I cannot but feel the enormous creative energy put into such tiny parts of a small tea-ceremony room, a small garden, or a living quarter, and the small portion of space in front of one's eyes. One realizes that the parts are the object of creation and that the whole is a mere outcome of "the aggregation of the parts."

# rganic Form

Organic form, such as that found in nature and in the biological world, is a natural form without straight lines. When an attempt is made to create a free organic form by breaking away from artificial geometric form, if that organic form is not entirely based on forms that have been completed, then it is inevitable that the whole will be created by piling up parts. It is possible to design the whole by methods of geometric design, but in order to design an organic form, it is necessary to design "from parts to the whole." It may be said that the Japanese sensitivity to the parts preceding the whole offers the strong possibility of creating an attractive organic form.

## Okayama Korakuen Garden, Okayama Prefecture 85, 86

In contrast to Western gardens, which pursue artificial beauty, Japanese gardens, despite being man-made, reproduce a natural landscape or ideal natural scenes as far as possible. At Korakuen Garden, creating islands, peninsulas, and beaches on a natural shaped pond that takes in the flow of the Asahikawa River results in a total configuration with a quite organic form. This is a strolling type of garden, where a stream flows across a large lawn, and where a pond, mountains, and teahouses are connected by passages. The garden is constructed so that the visitors can enjoy the changes of the scenery as they walk. Moreover, from the teahouses built at various points, it is possible to enjoy each scene of the pond and mountains, with Okayama Castle and the surrounding natural mountains visible in the background as borrowed scenery.

85  Sawanoike Pond and strolling passage (constructed 1687–1700). Although this is an artificial garden, it is intended to reproduce nature. It is configured by curved lines and surfaces seen in the natural world, and there are no geometric straight lines. It is in itself an organic form.

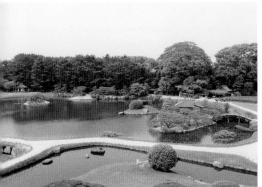
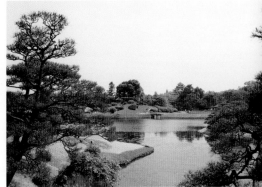

86 White sand and pine trees.
Natural ponds, islands, and a sandbar are reproduced, and the total scene is elaborated from these parts. Okayama Castle is incorporated in the background as borrowed scenery and the ideal whole is created from parts.

87 Site plan of Makino Tomitaro Memorial Hall (built: 1999, architect: Hiroshi Naito, location: Kochi Prefecture).

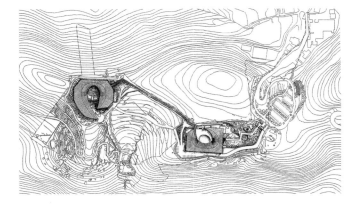

Korakuen is a noted garden with a bright and expansive atmosphere, where one can enjoy the seasonal changes.

### Makino Tomitaro Memorial Hall, Kochi Prefecture 87

The Main Building (on the right) and Exhibition Hall (on the left), two buildings consisting of two wooden vaults that stand on the ridge of Godaisan Mountain in Kochi City overlooking the city, are a part of the prefectural botanical garden, which is named after Dr. Tomitaro Makino, the father of Japanese botany. As for the architectural design, it was required to be in harmony with the natural landscape of Godaisan Mountain and to be a symbolic presence for the "Plan for a Cultural Prefecture of Trees," which Kochi Prefecture is promoting.

It was required that a building be designed with an organic form adapted to the ups and downs of the natural contours of the mountain ridge. And a design that symbolizes "tree culture" can be realized by practicing what I pointed out in "Craftsmanship and Skill of Master Woodworkers": "Wooden architecture is really an essence of the technique of bringing together wooden materials. There are materials (parts) at first, and the whole is created utilizing most of them." 88

The Main Building has an oval shape while the Exhibition Hall is shaped like a horseshoe. The buildings are constructed along the natural contour lines so as not to stand out from the landscape. Each of the roofs consists of continuous vaults of laminated timber beams that are said to suggest a fishbone. At first glance, the buildings look small and do not stand out. But once inside, one will be surprised by their scale. And as for the interiors, a lot of lumber has been used for finishing the roof, beams, walls, and floors, which is richly expressive. Inside the Main Hall, there is a projection room, a library, laboratories, a restaurant, etc., and in the Exhibition Hall, there are four exhibition rooms and a café. 89

This is an extremely effective example of coexistence with the natural landscape, but in order to achieve this organic three-dimensional space, enormous time and labor are required. For example, the lengths of the wooden beams all differ and therefore industrial production is of no use at all. Such charming architecture was only possible through serious effort by the architect Hiroshi

88 **Horseshoe-shaped Exhibition Hall.**
It is not possible to photograph the whole building in one shot. This building consists of continuous parts and is not intended to show the total figure.

89 **Exhibition Hall/ continuous wooden vaults.**
Characteristic fishbone-shaped wooden beams are the core of the design and structure. Enormous labor is required to assemble this structure because all the beams are of different lengths.

page 101:
90 **The innovative sketch that was presented in the competition. The organic pillars and the linear slabs were so impressive.**

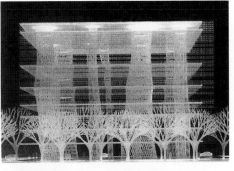

91 Tube-like pillars penetrate slabs fluttering like seaweed. Is it possible to construct this?

92 Façade of Sendai Mediatheque (built: 2000, architect: Toyo Ito, location: Sendai, Miyagi). Was it possible to realize the original image? Tube-like pillars that fluttered like seaweed stand statically and seem to act in unison with the zelkova trees on the street.

93 Tube-like pillars. The pillars and floor slabs of this building are fabricated by welding steel pieces.

Naito and those involved in the construction. This is the sincere attitude of the Japanese toward creation, which I described as "craftsmanship" in the chapter of this book on woodworking.

### Sendai Mediatheque, Sendai, Miyagi Prefecture 90, 91

Toyo Ito's few sheets of sketches that he presented in his plan for the design competition for this building featured tube-like pillars penetrating the slabs fluttering like seaweed; the slabs were as thin as mere lines and everything was wrapped in a glass box like a water tank. This completely new and striking concept pursuing what it described as architectural freedom won in a competition against over 200 presentations, and for the following six years, Ito had to struggle with numerous structural designers and contractors to realize the idea that he had submitted. This multipurpose building was finally completed and won a great many prizes. Ito presents striking ideas for each of his works, and he is regarded as one of the most innovative and influential architects not only in Japan but also in the world. 92

Sendai Mediatheque is a seven-story public building, and the entire structure is covered by a double skin of transparent glass

in each direction of its fifty-meter-by-fifty-meter floor plan. The main structure consists of tube-like pillars that are made of steel pipes and steel-framed flat slabs supported by shipbuilding technology. The spaces within the pillars are used as elevator shafts, light wells, duct pipe shafts, etc. And it is extremely interesting that the organic form of these tube-like pillars resembles the trunks of the roadside trees in front of the building. The pillars and the trees visually overlap and assert their coexistence, while the appeal of the glass architecture is very weak. 93

It is the repetition of manual welding that made it possible to create this attractive organic structure. The irregular shapes of the tubes have to be determined one by one. Each decision determines the constitution of the overall figure. This is a gift of the "parts-precede-the-whole" creative approach.

### Teshima Art Museum, Kagawa Prefecture 94

Female artist Rei Naito and architect Ryue Nishizawa were asked to realize the concept of "the unification of art and architecture" and "to create a base to send positive energy from Teshima, having understood the history of Teshima," as Soichiro Fukutake, the chief director of Naoshima Art Museum Foundation, imagined (Naoshima Fukutake Bijutsukan Zaidan 2011). Naito created an artwork using water in which a spring is born every day from morning to night. Nishizawa primarily aimed at the unification of environment, art, and architecture. The result of this collaboration was the birth of a particularly fascinating art museum.

94 Site plan of Teshima Art Museum (built: 2010, architect: Ryue Nishizawa, location: Kagawa Prefecture).

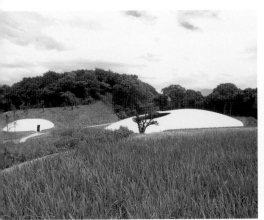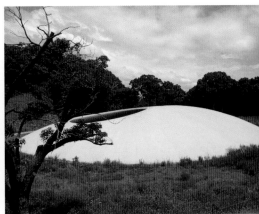

**95   It is like a UFO.**
The museum building (right)
and shop and restaurant
(left) in an organic form
called a drop of water,
which dissolves into the
surrounding landscape by
adjusting itself to the land-
scape's undulations.

**96   The sculpturesque
concrete shell.**
The gift of the attitude
as if creating a sculpture
according to the architect's
sensitivity.

The structure is covered by a one-piece concrete shell and Nishi-
zawa elaborately worked on every part of the up-and-down curves
of the shell in order to harmonize them with the surrounding
environment. As a result, the organic form that was achieved
completely melts into the surrounding nature and is called a
drop of water. It really is the birth of an art museum unified with
nature. 95

The form of the concrete shell is not the result of geometric ne-
cessity but the aggregate of parts that Nishizawa created like a
sculpture because of his sensitivity toward nature. This was only
possible by utilizing the newest technologies in such fields as
computers, surveying, and construction. 96

As a result, the interior space is so fascinating that it invites one to
imagine something never experienced in daily life. It may remind
one of a religious space, but there is no unified or centripetal aim
based on the total design, as there is in religious architecture. Cer-
tainly, this is a place where nature, art, and architecture resonate.
The work of Rei Naito is, in its scale, so small compared to the
architecture. Waterdrops from fountains join together to produce
flows of water. To collaborate in such a tiny work, it is necessary
to pay maximum attention to every small part of the structure.
Parts precede and the whole comes after as the result. Even then,
it is inevitably the best architecture as a whole. 97

There is a large hole on the shell and this part of the interior is
completely unified with the exterior. Bright sunshine pours in
and a pleasant breeze is occasionally felt. Even when there is no

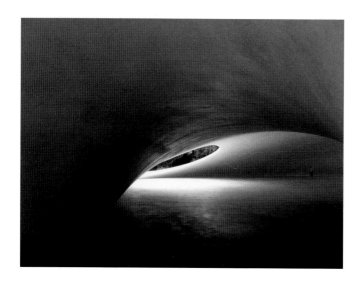

breeze, one can notice the flow of air by the movement of ribbons and threads hanging in the space, which are the work of Naito. One will clearly notice the birdsong and the sound of cicadas in the hall, which are sounds that cannot be noticed outside. Looking upward through the hole, one will once again become conscious of the clear blue sky, innocent white clouds, and deep green of the trees. Here, each of the five senses is sharpened and activated. Here and there on the floor of the hall, water drops spring out and flow, join together, and grow. What will one feel, in the experience of such living evidence, through such stimulated sensitivities? Everyone visiting here sits on the floor and meditates. The internal space is somehow quite comfortable. This may be because the outline surrounding the space is organic and natural, and the geometric enclosure remains unnoticed. 98
As one moves about in the hall, the exterior seen through the hole is quite different. Springs on the floor and drops of water vary. When interviewed, the staff who spend their days in this art space answered:

> This art space definitely consists of an aggregation of parts. The impression of the space differs completely according to place, time, weather, season, etc. Every morning, we start with wiping off the water, gathering fallen leaves, wiping and cleaning the floor, and we find that the drama that develops in each part of the hall is so diverse. We can't but feel the great energy that has been infused into every part of the space.

97   Interior of the museum hall.
The structure is planned so as to prepare for the delicate water drops of Rei Naito that spring out, join together, and grow to become flows of water. The structure requires maximum consideration of the detailed parts of the architecture. This space consists of the elaborate aggregation of those parts.

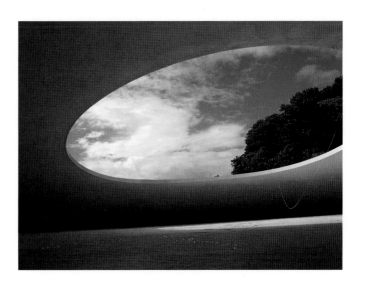

It is obvious that this space has been created primarily by the aggregation of a careful devotion to every part of the total structure.

For those architectural structures of natural organic forms that have been encountered so far in this chapter it is evident that the creation process, in each case, involves parts preceding the whole being seriously considered, and that the creation process is the result of the individual production of single articles.

Mass production of such structures is completely out of the question, which, however, makes it possible to sense the depth of architecture that is brought about by intensive labor. The charm of Japanese architecture is based on an original sensitivity that cannot be measured by Western rationality. It could be said that this is where the characteristics of the Japanese identity that aims to create "from the parts to the whole" is clearly revealed.

# Sense of "*Oku* = Inner Zone"

A distinctive feature of Japanese culture is that each part of the whole has its own independent meaning, which coexists with and composes the whole. Among the parts, some order is likely to appear. Among those that may appear, the sense of *oku* is particularly Japanese.

When it comes to *oku*, there is something that appeals to Japanese people. Conversely, it is extremely difficult to translate that feeling into Western words. In terms of Japanese sensibility, "*oku* = inner zone" refers to feelings that are more sacred, more noble, more private, or more secret. In Japanese houses, the *oku* room or *oku* parlor is the important room in the back, and in daily life Japanese people are deliberately conscious of *oku*. It is said that "housewife = *oku* mistress," derived from the most important presence.

In the *Kokin Wakashu* (Collection of Japanese poems of ancient and modern times), one finds this well-known poem by Saru-maru no Taifu, who was a *waka* poet in the early Heian period:

> *oku yama ni momiji fumiwake naku shika no kowe kiku toki zo aki ha kanashiki*
>
> (loosely: Far up in the mountains, as I hear the cries of deer trampling over the maple leaves, oh! how sad the autumn feels to me!)

As seen in this poem (far up in the mountains = *oku*), from ancient times we Japanese have cherished special thoughts on *oku* compared to Western people's yearning for height.

My own feeling of the sense of *oku* is also interesting. When I enter a Japanese-style inn and am guided to the back along a

tortuous corridor, I probably say, "Yes, a good room in *oku*!" But in Western culture, when I enter a Western-style hotel and go up to the room, farther and farther from the elevator, I might often claim, "No, what an inconvenient room!"

Japanese people are very keen on this sense of *oku*, which leads to characteristic arrangements in order to express peculiar feelings (Kato 1979). Here, I will look at various forms that are brought about by this sense of *oku*. The inner zone does not necessarily mean physical distance on a flat plane. Rather, it can be created by means of diverse arrangements. One feels the order of the co-ordination of space at each gate and corner as one proceeds to the inner sanctuary of a shrine. In the course of the approach, crossing a body of water implies that one is being cleansed by the water before entering *oku*.

What is important is that the sense of *oku* and its production and composition as the expression of this sensitivity are only realized through the accumulation of parts, which is the theme of this book on the "formative development from parts," and through the spatial hierarchy of parts. It may be said that *oku*, which is an extreme spatial perception common to the Japanese, is a gift of the Japanese creative principle "from the parts to the whole."

Let's look at the various forms in which the architectural set up of *oku* and the design of parts appear. Yet at the same time, it may be said that the intention of the production of *oku* lies hidden in the background of these characteristic designs.

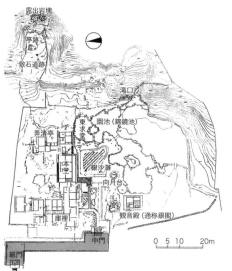

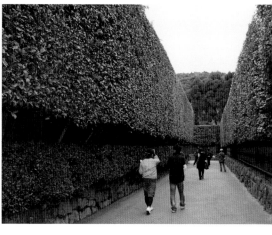

## Main Approach to the Ginkakuji Temple (Silver Pavilion), Kyoto 99

Here is the approaching path to the Ginkakuji Temple from the main gate to the inner gate. This approach plays a major role in the layout of the precinct. Visitors cannot enter the garden directly from the main gate but are forced to walk a distance and make two right-angled turns. A fifty-meter-long approach space surrounded by bamboo fences called the "Ginkakuji hedge" was thus created, and this space is quite effective in demonstrating the concept of *oku*. Some talk about the defensive implications of the approach, but away from the hustle and bustle of the city, this space in fact has an absolute effect as an approach to the world of Higashiyama culture of the mid-Muromachi period. 100

## Nezu Museum, Tokyo 101

The space of approach to the newly rebuilt Nezu Museum in Tokyo, which was designed by Kengo Kuma, is nothing but a production of *oku*. Away from the bustle of the capital's Aoyama district, where there are many fashionable boutiques, it is an introductory space to a silent art museum. And at this point we change our mind-set, become calm, and ready ourselves to enter the world of art.

Entering from the front street, we see that the structure of space has a particular effect (the composition of this particular part of the whole) created by making two orthogonal turns. This space and its effect can be said to be the product of Japanese DNA that has been cultivated through the long history of Japan. 102

99   Site plan of Ginkakuji Temple (founded in 1490).

100   Approaching path and the "Ginkakuji Hedge".
A unique space where visibility is restricted and a feeling of depth more than actual distance is recognized.

**108**

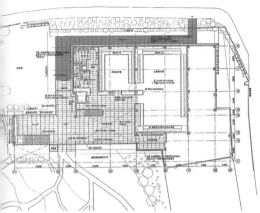

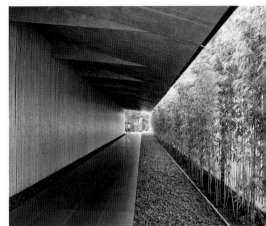

### Dazaifu Tenmangu Shrine, Fukuoka Prefecture 103

The production of *oku* at Dazaifu Tenmangu Shrine is quite in-
teresting. The main approaching path to the shrine first passes
through a line of souvenir shops, then makes a left turn and goes
straight through a tower gate to the main building. In between,
visitors cross two big arched bridges over Shinjiike Pond. A vis-
itor is purified by crossing the water, but more importantly, as
one goes up and down the arched bridges, the sight of the main
building accordingly appears and disappears. The layer of space
is thus acknowledged and, layer by layer, one proceeds to *oku*,
which is the most sacred space. Within a linear approach space,
there lies an admirable production through which *oku* is to be
acknowledged.

Similarly, a representative straight approaching path is found at
Tsurugaoka Hachimangu Shrine in Kamakura, where there is a
great difference in the level of the ground as one proceeds. In this
case, the great stairway plays a major role in the configuration
that allows one to recognize the feeling of *oku*.

### Fushimi Inari Taisha Shrine, Kyoto 104

This path leads to the inner precinct of Fushimi Inari Taisha
Shrine. This place is called the "Senbon Torii," meaning a thou-
sand torii gates. It is so unique that one will not find a similar
place. Fushimi Inari Taisha is worshipped as a god for prosper-
ous trade, and individuals who were successful in their business
donated each of these red torii gates, built in a consecutive series

that forms this unique tunnel. The custom of making a donation started a few hundred years ago, in the Edo period.

All torii gates are colored in vermillion and natural daylight penetrates through the limited gaps between them. An extraordinary space thus emerges. As an approaching path, its fearsome and superstitious atmosphere is so effective that all those who walk through it experience something of a divine feeling.

## Himeji Castle, Hyogo Prefecture

The main approach route leading to the castle is configured in a way that might be mistaken for a maze and its defensive intention is apparent, but it is also very effective in creating a sense of *oku*. As a matter of fact, Himeji Castle has never endured the fires of battle and it can be said that the major significance of its existence is the establishment of the authority of lords during peacetime. When entering the castle, it is not easy to get close to the towering keep or the main enclosure. There are gentle and steep slopes, numerous gates, narrow paths, U-turns, three-way blind alleys, etc. All sorts of devices are worked out and this could be said to be the ultimate creation of *oku*. 105, 106

## Approach to Meiji Shrine, Tokyo 107, 108, 109

At Meiji Shrine, which was built in the Taisho period (1912–1926), the traditional spatial structure that is peculiar to Japan still breathes and the production of *oku* is fully shown. Just a few minutes' walk from JR and Metro stations, one enters the

103  Approaching path to Dazaifu Tenmangu Shrine (originates from the tenth century).
Arched bridges are repeatedly set as parts on the approaching path, and the change of views and up-and-down movements let one feel the depth or *oku*.

104  Peculiar space at Senbon Torii gate.
Continuous torii gates, which regulate territories, create an extremely strong introductory space. Torii gates are multilayered and the sense of *oku* is strongly recognized. Furthermore, natural daylight penetrating through the limited gaps emphasizes the multilayers. This is an incidental result of consecutive donations over the years, but it can be said that this is a quite peculiar space that was created by the sensitivity of the Japanese consciousness of *oku*.

**110**

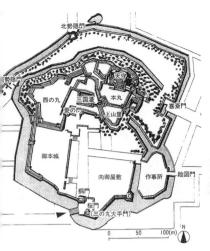

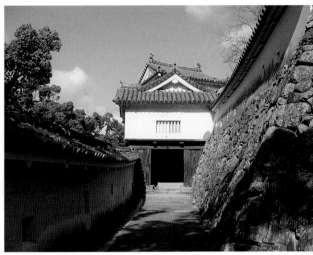

105 Site plan of Himeji Castle (overall structure of the castle was completed around 1618).

106 Ni-no gate and narrow path.
Bottleneck paths, which seem not to be regular routes, numerous gates, and U-turns make up the sense of *oku*.

precinct of the Meiji Shrine. At first, one is conscious of entering the precinct by going through the First Torii Gate and as one proceeds, one crosses a stone bridge (Sacred Bridge) in order to be purified.

Here, the approaching path curves gently around and cannot be seen farther inside; our expectations for the next development thus increase. After a while, a big left turn is made and there is the Second Torii Gate (Grand Torii); by going through it, one becomes aware of entering the higher-ranked zone. 110, 111, 112

If one proceeds farther and makes a big right turn, the Main Hall can be seen in the distance. Proceeding farther, through the (last) Third Torii Gate, one enters the most sacred zone. After going through the Middle Gate, one encounters the Sacred Garden in front of the Worship Hall. Several steps have been constructed in front of the Worship Hall in order to emphasize its higher rank, and this is the farthest one can go, unless one is a priest. At this point, one faces the Main Hall to pray. The inside of the Main Hall can be seen, and there are some stairs, at the top of which is an altar whose doors are closed, hiding the interior and intensifying the mystique. In this way, the hierarchy of each part in the precinct is multilayered and the presence of *oku* is significantly produced. 113, 114, 115

It is thus understood that, in order to produce mystique and to constitute a sense of *oku*, various methods and techniques must be combined.

1 Go through torii gates multiple times to be aware of entering a higher precinct.
2 Purify oneself by crossing water.
3 Follow an approaching path, taking a gentle curve so that further development cannot be foreseen.
4 By making big turns, acknowledge that one is entering the next zone.
5 Construct gates to insist on difference between territories.
6 Create differences in ground levels to emphasize the hierarchy of zones.
7 Hide as much as possible to increase the construction's mystique.

It can also be said that these methods and techniques are aimed at giving significance to every part that configures the whole.

As mentioned above, each part of the whole has its own independent meaning, and among the parts, some order is likely to appear. This is the origin of the sense of *oku*. "Parts precede the whole" and "the whole is composed of parts," and this process produces a spatial hierarchy.

Moreover, *oku* has various implications, including authority, nobleness, secrecy, mystique, importance, elation, privacy, etc. The sense of *oku* cannot originate in processes of "the whole picture is shown" or "the whole precedes the parts." The sense of *oku* and the notion of "parts precede the whole" are inseparably related.

107 First Torii Gate.

108 Sacred Bridge.

109 Make a big left turn.

—

110 Second Torii Gate.

111 Third Torii Gate and view of the Main Hall.

112 Middle Gate.

—

113 Sacred Garden.

114 Ground level difference and Worship Hall.

115 This is as far as one can go.

# Do Not Show the Whole

Generally in Western architecture, configurations show off the majesty of the whole, but in the process of Japanese architectural creativity, configurations often appear that dare not show the whole. In the case of an approach to a building, the axis and the outlook are, in the West, considered important, and the whole picture of the building can be viewed from far away. But it is quite different in Japanese configurations. By not letting the whole picture be seen, it is possible to reveal the spectacular scene suddenly as a surprise or to arrange the production of *oku*, as the previous chapter explained. A clear contrast between the West and Japan can be seen. This clearly shows the characteristic of Japanese sensibility that is the "now = here" principle, which sees the whole from here, and in which the parts have priority over the whole.

## Total Image of Architecture

In this photograph looking back from the dome of St. Peter's Basilica in the Vatican, one can see the magnificent Piazza San Pietro in front of the sanctuary, in the center of which stands an obelisk, and the approach road heading to the cathedral. Everything is planned on an axis, and it is intended that one will strive to reach the dome from far away and, upon arriving at the plaza, will immediately grasp the whole aspect of the grand cathedral. 116
By contrast, in Japan, at Izumo Taisha Grand Shrine—one of the most distinguished shrines from ancient days, as can be seen in the photograph—the Copper Torii Gate, Worship Hall, and Main Hall are slightly misaligned from the axis of the path of

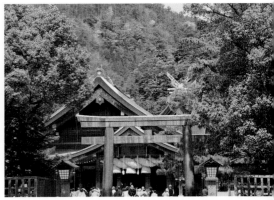

**116 Piazza San Pietro in the Vatican (present basilica: completed in 1626).**
Looking back from St. Peter's Dome, it is understood that pilgrims approach from far away, heading for the magnificent sanctuary that is their ultimate goal.

**117 Izumo Taisha Grand Shrine (origin of the shrine goes back to the days of Shinto myths; the present Main Hall was built in 1744).**
The Main Hall of Izumo Taisha is a grand structure. But its existence is meant to be felt and the whole image is never exposed. It is important to care about how each part of the whole appears.

approach. The Main Hall itself cannot be seen directly, but its existence is suggested by the appearance of characteristic cross finials on top of the roof. Due to the fact that the buildings are slightly misaligned, the overlapping of the buildings is recognizable, and the existence of a spatial layer seeps into our consciousness; the feeling of greater depth in the given area is thus strongly acknowledged. The existence of each part is clearly recognized. And the intention of the configuration not to show the whole is evident. 117

### Configuration of the Space of Approach 118, 119

"The Long Walk" to Windsor Castle in England allows visitors to approach the building while grasping a total image of the castle. It can be said that this sense of absolute distance represents the dignity of the building.

By contrast, on the main path of approach to Ise Jingu Inner Shrine, one crosses the Ujibashi Bridge in order to mentally purify oneself in the clear stream and enter the precinct. As soon as one crosses the bridge, a right turn is made and one proceeds through the precinct forest, following a gently curving path. Meanwhile, one has no idea where the Main Hall is. Suddenly, making a left turn, one climbs a number of steps and there appears the Main Hall of the Inner Shrine, which itself is allowed to be seen only by Shinto priests because it is enclosed within a fourfold wooden fence.

Unlike people in the West who will compose the whole in a clearly logical manner and show the whole aspect, it is important for the Japanese to accumulate parts and to produce a sense of *oku*. In this way, the Japanese attain a more holy and solemn feeling.

118   The Long Walk, Windsor Castle, England.

119   Entrance bridge of Ise Jingu, Inner Shrine.

### Case of an Approach to a Private Space

The Herrenchiemsee New Palace, which was built on Herreninsel (gentlemen's island) by the Bavarian King Ludwig II on the Chiemsee, Bavaria's largest lake, about sixty kilometers southeast of Munich, was meant to be a replica of the Palace of Versailles, which had been built by French King Louis XIV. Both this grand approach, which can be called the complete form of the French garden, and the setting are designed to let visitors feel an emotional upsurge as they approach the palace's main façade. 120

Conversely, the approach to the Katsura Imperial Villa in Japan has a completely different appearance. If you enter through the front gate and proceed to the simple Miyukimon Gate, you cannot understand the total structure of the villa at all except for this humble gate. Inside the gate, only a hedge is to be seen. As soon as one passes through this gate an orthogonal right turn is made, but still one cannot grasp the whole image. In Western culture, it is obvious that social status is expressed by an absolute sense of distance, grandeur of scale, and magnificence of arrangement. But it can be said that Japanese sensitivity, which intends to express dignity by refinedness, profoundness, and the production of *oku* is antipode to this intention. 121

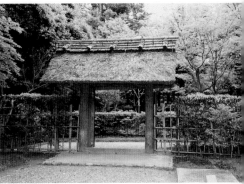

120   Herrenchiemsee
New Palace, Germany
(constructed 1878–1886,
uncompleted).

121   Miyukimon Gate,
Katsura Imperial Villa.
The intention not to let one
see the whole is obvious.
Each part of the whole has
its own meaning as one
proceeds.

## Vista of a Garden and its Development

When one goes out onto the terrace of the Nymphenburg Palace in Munich, Germany, one sees the grand vista of a magnificent garden and waterway that continues in a straight line for several kilometers. Absolute length asserts the possession of a vast territory. 122, 123

By comparison, upon going through Miyukimon Gate at Kamino-ochaya (Upper Teahouse) of the Shugakuin Imperial Villa, one climbs the steps carefully through clipped shrubbery. But the vista does not work at all. Once one reaches the top, there is a simple pavilion, Rinuntei, and suddenly the entire garden vista is completely revealed.  Excellent borrowed scenery with superb views of the pond, its islands, and the surrounding Kyoto hills is provided, as seen in the photograph. This is the wonder of the vista itself and the sudden change.

There is a great difference in the creation process, namely, the difference between the attitude of Western culture, which tends to reveal everything, and that of the Japanese, who try to create significance in each part without showing the whole image and to show the resulting change most effectively.

## Unobstructed View 124, 125

When one enters the Mirabell Gardens in the ancient city of Salzburg, Austria, which is said to be one of the most beautiful baroque gardens in Europe, one notices the strong axis in the total arrangement, which can be seen not only within the garden but

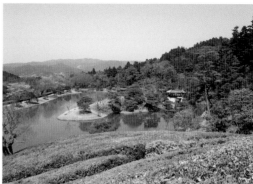

also in the vista of Salzburg Cathedral and all the way to Hohensalzburg Castle. This is definitely a configuration that lets one acknowledge the great axis in a city.

But at the Katsura Imperial Villa in Japan, arrangements that prevent one from grasping the whole image are clearly seen. This photo is of the Sumiyoshi Pine Tree along the path from the Miyukimon Gate to the Main Building. This tree is clearly an eye-stopper, the intention of which is not to let one see the whole, although the lake is partly visible. The design aims to concentrate on "now," "here," and "what is in front of the eyes" rather than the "whole aspect" and the "whole image." The intentions of these two different examples and their differences clearly mark a great contrast.

As described above, the characteristics of the Japanese configuration of space can be clearly understood in contrast to those of the West. In Western culture, it is a common belief that the wonder of a geometric configuration is recognized through its geometric spatial structure and a perspective of the whole. However, in Japan, parts insist on their independence and importance by hiding and blocking the view of the whole, and this moreover creates characteristic Japanese architectural sensitivity such as *oku*.

122   Nymphenburg Palace, Germany.

123   Shugakuin Imperial Villa, Kyoto (constructed 1653–1655).
This spectacular borrowed scenery is revealed suddenly after climbing through clipped shrubbery.

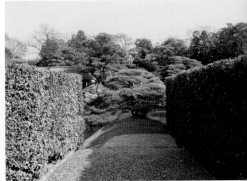

**124  Mirabell Gardens, Austria.**
The emphasis of the axis to Hohensalzburg Castle a few kilometers ahead is the main subject of garden planning. The geometric configuration influences its details.

**125  Katsura Imperial Villa, Kyoto.**
This is a typical eye-stopper. A pine tree is placed so the whole cannot be seen. It is important to express *oku*. The greatest care must be given to the part in front of the eyes.

# FORMATIVE DEVELOPMENT FROM PARTS

# Parts Precede the Whole/ "Now = Here" Principle

"Japanese people see the whole world from here, not from the whole of world order, see the part = Japan = here. The structure, or the Japanese way of looking at things ... does not appear to have changed fundamentally," says Japanese literary critic Shui-chi Kato in his work *Time and Space of Japanese Culture* (Kato 2007).

From the viewpoint that "parts precede the whole," it is possible to understand various interesting points when one compares the society and culture of Western countries, and those of Japan; as a result, the characteristics of Japan will become much clearer.

It is interesting to compare the Paris Metro and the Tokyo Metro. The Paris Metro operates 14 lines and 297 stations, and the first line started operations in 1900 at the same time as the Paris Exposition. The whole network was planned from the outset and, by 1930, all lines were completed. Meanwhile, the Tokyo Metro (including the Toei Subway) operates 13 lines and 249 stations, and its network is similar in size. But the difference is that, since the start of Ginza Line operations in 1927, each line of the Tokyo Metro has been planned and added one by one, according to necessity and without having any total plan. The total network was completed as a result of these additions.

What is notable in this comparison is that the Tokyo Metro, which was constructed without any overall picture, is as efficient and convenient for users as the Paris Metro. It is not inferior in any way. It can be said that Japanese creativity possesses the ability to create the best possible total from the most suitable parts.

By contrast, according to studies of Japanese manufacturing industries carried out in large part by researchers at MIT (Massachusetts Institute of Technology) in the 1980s, so-called *kaizen* activities, which had attracted worldwide attention, were praised as the source of the strength with which Japanese manufacturing dominated world manufacturing at that time. According to these studies, it was by individually optimizing each plant that these *kaizen* activities were able to realize the best possible total; they were certainly also good examples for showing the characteristics of the Japanese in the greatest way possible.

This "way of looking in which parts precede the whole" should also play a major role as a distinctive feature of the Japanese when a building or an architectural space is being constructed. For it will lead to a hypothesis that "Japanese architecture is designed from parts and then configured as the whole." In other words, no total picture is imaged at the beginning, and parts are created one by one in the most proper way; as a result, the best possible total is produced as the whole. This procedure is quite different from the Western way of creating.

In chapters 1 and 2, I looked at the characteristics of Japanese architectural creativity and the characteristics of Japanese architectural composition. I have also noted that the "parts-precede-the-whole" philosophy has always been in the background and greatly influenced these characteristics.

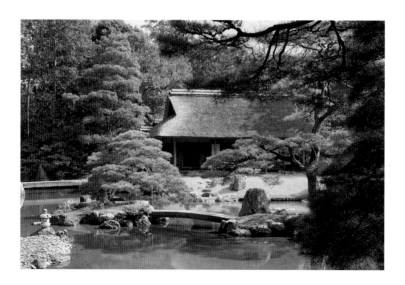

In this chapter, I will investigate this philosophy through concrete examples in order to look at what is meant by the notion of "design from parts and configure the whole."

## Examples for Investigation
### Katsura Imperial Villa, Strolling-Type Garden, Kyoto 126

The garden of the Katsura Imperial Villa, which is designed in the *kaiyu* (strolling) style, is an assembly of partial optimization. In Japanese gardens, landscape is configured by organically combining a pond, islands, bridges, stones, and trees; these elements' individual appearance in their specific location and their details are extremely important. In addition, architectural structures play a key role in the garden as a specially added element because of their visual performance and location. As the rationale of the garden's design, miniature views associated with natural places of beauty across the country are incorporated, including Amanohashidate from Tango, the hometown of the princess of Imperial Prince Tomohito, who is the creator of the whole garden. In addition, the approach is to optimize every part, right up to the steppingstones around buildings. With all these parts combined, the great spectacle that varies as one strolls through the garden can be appreciated. Whether or not there was a total image at the beginning is not the question. From the result, it is obvious that the challenge was to create the best possible total on the spot.

126 Amanohashidate Bridge and Shokintei Teahouse.
The main constituent in the strolling garden is "a moving person." The garden consists of a pond, islands, bridges, stones, trees, and buildings—each of which is elaborately created. The landscape is configured by setting up these parts, and a person in motion appreciates the garden by combining the respective parts.

127 Steppingstones
of the approach to Old
Shoin.
From such parts and each
detail, it is clear that the
willingness applied to their
creation is tremendous.
From examination of the
materials to the inventive
ideas of the form, it is obvi-
ous that a great deal of hard
work had been put in.

128 Steppingstones
from Old Shoin to
Shokatei.

129 Steppingstones
under the eaves of
Onrindo.

Let's look specifically at how committed these examples are and
how they invest energy to design their parts and details. 127, 128,
129

**Dogo Hot Springs Bathhouse, Ehime Prefecture** 130

The bathhouse's main building is a large-scale architectural com-
plex mainly consisting of three-story wooden structures built
basically in the Japanese style from between 1894 and 1924.
To mark the 100th anniversary of the original buildings, the
complex was designated as an Important Cultural Property of
Japan, the first such designation for a public bathhouse. The
characteristic and imposing structure is well known nationwide
and has become the representative face of Matsuyama. Although
the main building is not exactly Japanese-style architecture, it
was built by master carpenters based on traditional techniques
related to castle architecture. Extension work was carried out as
needed (main extensions were added in 1894, 1899, and 1924),
thus completing the present complex. The construction work
was carried out without a final image, and the overall form of the
building is very complicated since it is a combination of various
parts with different functions. As a result, its powerful presence
and total cohesiveness are worth mentioning.

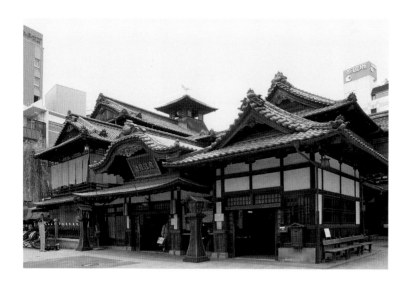

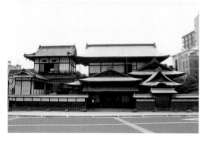

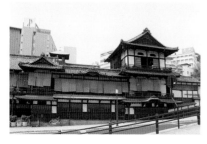

**130 Main façade of the building complex. (West elevation)**

An overall plan did not exist at the beginning of the construction. Extensions were added and, as a result, the present appearance was achieved, which now constitutes the imposing face of Matsuyama. This is a representative example of the principle that parts precede the whole.

**131–133 South elevation, East, North.**

134  Friedrichsbad,
Baden-Baden, Germany.
The total perspective of the
whole was drawn in the
beginning of the construc-
tion, and then each part of
the building was elaborated
accordingly. The whole
picture exists first.

As a bathhouse complex, the building completely occupies a whole block in the busy city and the building's four elevations are quite distinct, each showing their respective characteristic functions. Elevations created spontaneously maintain a unique flavor and some kind of order is felt. 131, 132, 133

By comparison, the German spa resort of Baden-Baden contains a hot-spring facility that was built almost at the same time as Dogo Hot Springs Bathhouse. This is Friedrichsbad, which was completed in 1877 and has undergone repeated luxurious interior renovations, although the initial overall picture of the building is protected. While it is natural that there are great differences in the design and in use of materials in the East and West, this is a perfect example of the contrast between the Japanese way of creation, in which "parts precede the whole," and the Western way, in which a total image of the whole exists from the beginning. 134

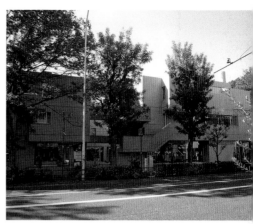

### Daikanyama Hillside Terrace, Tokyo 135, 136

When visiting this unique neighborhood, one encounters a comfortable atmosphere surrounded by a group of charming and unified buildings. These are multiple complexes of housing, offices, and shops, which were completed after seven periods of construction from 1969 to 1998 and all designed by Fumihiko Maki.

The buildings are harmoniously designed, utilizing the vocabulary of Modernist architecture. The height of each building facing the main street is limited to ten meters so as to create a single townscape. By dividing the mass of each building, the unified scale is maintained. Spatial layers, which produce the spatial depth, are deliberately incorporated by means of interior and exterior spaces and trees. The color code is naturally observed. Multiple recurrent passages are designed so that one may enjoy the spatial continuity, and white round columns are characteristically placed at the corners.

Here, throughout the seven phases, the best design possible according to the needs of each phase has been realized; by combining these designs, a charming and harmonious neighborhood has been completed. At the beginning, such an expansive site was not conceived. Nonetheless, the townscape as a whole is no doubt wonderful. This is typically the case where perfectly designed parts are combined and the ideal whole is created, which is a characteristic aspect of Japanese creation. 137

135 First phase completed in 1969.
This photo shows the first stage of the development that continued for seven phases over thirty years. Various town planning techniques based on Modernism were practiced from the beginning of the process. At first, the scope of the development was unknown, but various techniques connected to the next phase were already incorporated everywhere.

136 Second phase completed in 1974.
At this stage, enclosed courtyards were discussed, and the layers and depth of space were to be considered. Techniques to achieve various charming urban spaces have been practiced.

第4期(ヒルサイドアネックス)1985　アネックスA棟　第1期1969　第5期(ヒルサイドプラザ)1987　第2期1973　第3期1977　デンマーク大使館1979　大手会館　朝日会館　第6期1992　ヒルサイドウエスト1998

137　General view
drawing of Daikanyama
Hillside Terrace
(Phase 1–Phase 7).

## Drawing of Jo-yugain Residence, Ninnaji Temple, Kyoto

In ancient times, how did the Japanese create buildings? It is quite difficult to grasp the actual state of Japanese buildings before the Middle Ages.

It is said that the *Drawing of Jo-yugain Residence, Ninnaji Temple* (1509)—an Important Cultural Property of Japan showing in detail the layout, including gardens and attached buildings, of the residence of the head priest of a distinguished temple—is the oldest and the most important document to which we can now refer.

When we look at the drawing, the total layout of the entire residence is comprehensible. Centered on the main building facing the gardens in the east and west, the Buddhist hall, kitchen, bathroom, and other buildings spread out. The development of the residence is visible, and the structures were not likely to have been built according to the initial plan as a whole. It is understood that the configuration of the residence is the result of considering the relationship between buildings and gardens, and of attaching importance to the function of each building. Even in those days, it could be said that this architecture clearly showed the characteristic of Japanese creation that the best possible total as the whole derives from making the best of partial creations. 138

138   Drawing of
Jo-yugain Residence,
Ninnaji.

### Kumano Hongu Taisha Shrine

There is another document that shows the composition of Japanese architecture in ancient times. It is the National Treasure of the Kamakura period (1185–1333): *Ippen Shonin Eden* (Illustrated biography of the itinerant monk Ippen). Within the document, there is an illustration showing the appearance of the shrine in those days. It is possible to understand that the total layout was not regarded as important and that each building that was part of the shrine was built according to the needs for that building at the place where construction was possible. It is said that the shrine, in those days, was built on the sands of the Kumano River, and in the Edo period (1603–1868) it was rebuilt but was washed away by a flood in the Meiji period (1868–1912). Four buildings that survived the flood, including the main hall, were then moved to the current high ground. Thus, rather than the entire configuration showing the formality of the layout as a shrine, the functions of each part were considered to be the priority. 139

### Townscape of Edo (former name of Tokyo)

When we look at an old map of the city of Edo in the Edo period (1603–1868), we can see that the city spread out around a center of Edo Castle, but that the castle was merely positioned in the center and that no centripetal feature can be recognized in the plan. Around the castle, the residences of three branches of the Tokugawa families, and of hereditary daimyo (feudal lords), outside daimyo, and direct retainers of the shogun, were

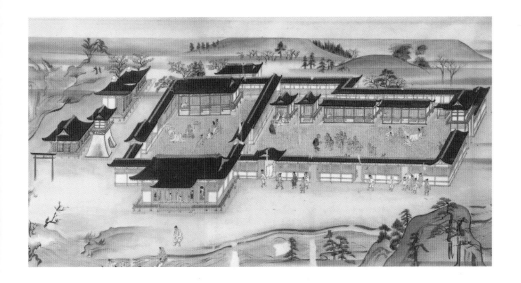

139 Ippen Shonin Eden
(Illustrated biography of
itinerant monk Ippen).

positioned in a spiral configuration. But no positive city planning existed.

The population of the city, which had developed throughout the Edo period, exceeded one million at the beginning of the eighteenth century, and Edo became one of the largest cities in the world. The towns within the city, which were called 108 (innumerable) towns, continued to multiply and sprawl in each of the city's parts. When looking at an old map in detail, one will notice the distinction of areas for samurai, merchants, and shrines and temples. As for areas for shrines and temples, a certain intention, which is said to be the influence of feng shui, is apparent. At the same time, town layouts depend on the geographical features of places, and it is likely that the whole is constituted by the aggregation of each part. That is to say, Edo is a great combination of countless parts—namely, innumerable towns. 140

As is shown in this case, even in the planning of a gigantic city, in Japan parts come first and the whole is constituted as the result. The overall logic of urban planning does not control and regulate the state of each part.

In his work *Miegakuresuru-toshi* (From Edo to Tokyo) Fumihiko Maki says:

> It is well known that the relationship between the whole image and each of its parts has always been regarded as important in the development of Western cities. The whole always had control over its parts, and when parts were to be emphasized, it was done with the strong intent of positive revolt

against the whole. It can be said that this has been the same for cities and architecture. By contrast, looking at the development of Japanese cities, I may say that, in the relationship between the whole and its parts, such Western recognition has been extremely weak. It is likely that the Japanese have strengthened the recognition that parts are in fact the whole, by finding independent space in a tiny, little space. In other words, what corresponds to a single house is, exaggeratedly speaking, the whole of nature, including natural features and climate. For example, in Edo, a castle town, they have developed spiritually such unique dual structures that, on the one hand, site allocation, building materials and design have been strictly determined according to social class, and, on the other, they have freely created such microcosms. (Maki 1980) As Shuichi Kato points out, the Japanese see the whole from "here," and do not recognize "here" from the whole. When looking at the divided lots of land in downtown Tokyo (Edo), we see that although these lots consist mostly of reclaimed flat land, the logic of each particular place such as a view or existence of a river has priority and an effective grid system through the area was never adopted. Original grids, the size and slope of which differ,

140   Revised map of Edo in 1844–1848.

**132**

have been created in each part of the area, and these are somehow connected. In uptown areas, there are many places where curvilinear axes have been adopted according to delicate alterations of topography and differences of elevation. The townscape of Edo, as seen on the map, is simply an aggregate of multiple parts.

**What is meant by "Parts Precede the Whole"**
So far, by employing concrete examples from individual structures to a group of buildings and beyond to an urban scale, I have demonstrated what is meant by "parts precede the whole." The characteristics of each case are summarized as follows:

1. Garden of Katsura Imperial Villa
   - Maximum passion for the design and finish of each part.
   - Greatest emphasis on the appearance in each place.
   - Do not show the whole view, but enjoy each change in the movement.

2. Dogo Hot Springs Bathhouse
   - Without having an image of the whole picture, the buildings were added according to the functional needs year by year.
   - The whole was completed as the result of a unique coherence.

3. Daikanyama Hillside Terrace
   - Sophisticated unification as a whole is wonderful.
   - Existence of common formative elements, colors, and scale.
   - Devices to give charm to the parts.

4. Drawing of Jou-yugain Residence, Ninnaji Temple
   - Mutual relations between rooms are of great importance.
   - The most proper combination of parts is considered rather than the total image of the whole.

5. Kumano Hongu Taisha Shrine
   - Four buildings were moved → Proof that shows "parts precede the whole."
   - Configuration and form of the whole has less significance.

6. Townscape of Edo (former name of Tokyo)
   - Aggregation of 108 (meaning innumerable) towns; each town (a part of the whole) has its distinctive character.
   - There is neither centripetal force nor general planning.
   - Each part has nothing to do with the whole.

As summarized above, an architectural structure (or a city) that is created by way of a design that moves "from parts to the whole" can be described as follows:

- First priority is to put in deliberate efforts and devices for creating each part.
- Mutual relations and connections among parts (especially between neighboring parts) regulate the total form.
- Each part is not necessarily conscious of the whole.
- The whole is completed as the result of an aggregation of parts.

It may be said that this is one of the most distinctive characteristics of Japanese architecture. What could be the cause of this feature? And what kind of architectural creation would this consideration of "parts precede the whole" bring about? It can be said that the total image of the results of such studies form Japanese identities, which is the main focus pursued in this book.

# Compositional Principles

In order to start from parts and create the whole as result, it is necessary to establish the existence of basic compositional principles. Japanese people have been trying to find the grounds to explain, justify, and practice the method of creation that starts from parts and comes up with the whole.

## Principle of *Ten-chi-jin* (heaven-earth-man)

In the world of flower arranging, an idea or a compositional principle of *ten-chi-jin* (heaven-earth-man) is often applied as the basis of the arrangement. In the vocabulary of flower arranging, *ten* is a heavenly body or sun, expressing "a thing to lead"; *chi* is for earth, expressing "a thing to follow"; and *jin* is for humankind in-between *ten* and *chi*, expressing both "a thing to harmonize" and that these three elements conform to basic branches in flower arrangement and express the entire space (see the website of the Ikebana Koryu-Rionkai, a flower arrangement organization).

What happens when *ten-chi-jin* is applied to architectural creation? In his work *Japanese Design Theory*, Teiji Ito says that *ten-chi-jin* is "a design technique to utilize free-shape elements" and "basically a technique that creates dynamic three-dimensional harmony using three elements of different form" (Ito 1966). Here, three elements may not be necessary, and when there are four, it is possible to apply this *ten-chi-jin* composition principle by regarding two out of the four as one and the total as three. When there are more than five, ideas could be developed in the same way. *Ten-chi-jin* makes the maximum use of each part

141 Composition
according to *ten-chi-jin*.

142 Ten-chi-jin Folly,
Echigo Hillside Park,
Nagaoka, Niigata
Prefecture (constructed:
1998, design supervision:
Hajime Yatsuka).
In being named ten-chi-
jin, the total figure bears
convincing and persuasive
characteristics.

and tries to create the best whole out of them, which is an important viewpoint and a significant explanatory compositional principle.

## 1 World of Flower Arrangement

There are many schools in the art of flower arranging and each has its own, original concept. The following is an abstract from the homepage of Ikenobo, the oldest and largest school of Japanese floral art, which interprets the composition of flower arranging according to *ten-chi-jin*. 141

> This arrangement is composed of basic branches that are likened to yin and yang (opposite forces that form a whole, from Chinese philosophy) and to *ten-chi-jin*, which had been the basis of composition since ancient times. These three basic branches are treated as one and grow straight from the water's edge. Focusing on the center branch, the other two mutually correspond and the total figure is composed so as to show the characteristic of elevated beauty. (Ikebana Ikenobo, website)

## 2 Ten-chi-jin Folly 142

The following is a comment on this folly by the design supervisor, Hajime Yatsuka:

> This facility is a folly consisting of three elements, "heaven," "earth," and "man." Namely, vertical heaven is represented by twin towers, horizontal earth by a boomerang-shaped

Donjon (completed in 1594)    29.4 m

Tatsumi
attached
tower

16.8 m

Tsukimi
tower
(con-
structed
in 1633)

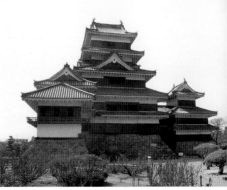

base, and intermediate man by a wooden basket. These three elements are composed in a discordant style. (Echigo Hillside Park, website)

In Echigo Hillside Park in the suburbs of Nagaoka City, Niigata Prefecture, this "Ten-chi-jin Folly" soars on the top of a hill that is reached after climbing 435 steps from the green Senjojiki (a 1,000-tatami-mat space). This is a creative work actually named Ten-chi-jin and, as this example shows, *ten-chi-jin* objects are freely composed by balancing three elements, and the whole becomes more persuasive when *ten-chi-jin* is employed as an explanation. It may definitely be said that this is a quite versatile compositional principle based on Japanese sensitivity.

3   Donjon of Matsumoto Castle

National Treasure Matsumoto Castle with its donjon (said to be completed in 1594) was originally built for warfare, and the main keep was a concatenate type consisting of a donjon, a connecting tower, and a smaller donjon. In the Edo period, Tsukimi (to enjoy the moonlight) tower and Tatsumi (southeast), which is an attached tower, were added. But these were built in a time of peace and not for warfare. As a whole, it is called a compound-type keep.

Naturally, extension work to the keep of the castle was conducted according to functional needs, but for such work in peacetime, the castle's performance, its beauty in design, and the enforcement of the lord's authority would have been equally as

143   Donjon (completed in 1594)/Tatsumi attached tower/Tsukimi tower (constructed in 1633).

144   Matsumoto Castle, the additional work of the Tatsumi and Tsukimi towers.

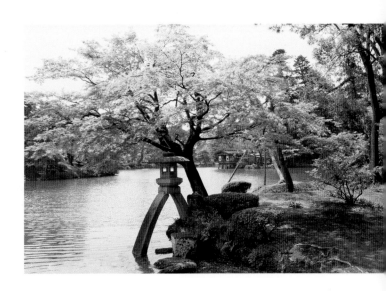

important. Considering the total balance, where and how should the additional work have been done? It is not difficult to imagine that a technique and logic for determining this additional work were required. 143, 144

In his work *Japanese Design Theory*, Teiji Ito says that "it may be said that the keep of Matsumoto Castle is a proper example of the application of *ten-chi-jin* in the architectural field. The merit of applying *ten-chi-jin* principles in architecture is the possibility of not losing the total harmony if additional work is done afterward" (Ito 1966).

Why can one say that this additional work does not influence and destroy the total harmony? This is simply the essence of Japanese sensitivity. While seeking harmonious beauty in the statistic static stability of symmetry constitutes the mainstream approach of the world outside Japan, it is the essence of Japanese identities to sense harmony in this unbalanced dynamic appearance.

4   Kotoji Garden Lantern of Kenrokuen Garden, Kanazawa, Ishikawa Prefecture

The Kotoji Garden Lantern and Kasumigaike Pond are the most popular spot for photography in the scenic Kenrokuen Garden in the city of Kanazawa. This two-legged stone lantern is, at a glance, quite unbalanced. But there is unique harmony and stability in this composition. 145

Can it be said that one feels stability and refinement by regarding this lantern as "*ten* = heaven," the spreading pond surface as "*chi* = earth," and the stone at the step of the lantern as "*jin* = humankind"?

146   The Honmaru Palace compound of Edo Castle.

### Movement Space

In his work *Space in Japanese Architecture*, Mitsuo Inoue refers to a characteristic of Japanese architectural space which he describes as the difference between geometric space and movement space. He says:

> In contrast to geometric space, which is represented by the space of Cartesian coordinates such as the Forbidden City in Peking and the space of polar coordinates as seen in European medieval city planning, the composition of space in our country is controlled by the principle of movement space such as seen in the Katsura Imperial Villa. (Inoue 1969)

In strolling-style gardens such as the garden of the Katsura Imperial Villa, new scenery unfolds whenever one takes a step, and the wonders presented by the change of views are most important. One's movement is required in the first place, and it is in this movement that the value is to be found. In contrast to geometric space where all elements of the space such as buildings, monuments, or fountains are placed under control of axes and coordinates, in movement space elements such as teahouses and arbors or bridges and plants are all freely placed in the most effective positions according to the movement of the viewer. The concept of movement space,

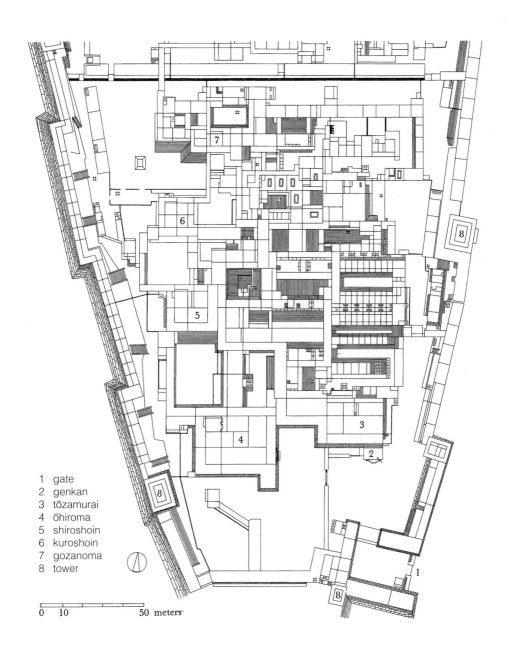

1 gate
2 genkan
3 tōzamurai
4 ōhiroma
5 shiroshoin
6 kuroshoin
7 gozanoma
8 tower

0    10              50 meters

the compositional principle of which enables the arrangement of compositional elements and the design of space, is noteworthy.

In movement space, the way in which each compositional element is connected and the mutual relationship between the elements are of major concern. Mitsuo Inoue mentions that the layout of the Honmaru Palace compound of Edo Castle is the most identifiable example of Japanese spatial composition. 146

The great number of buildings depicted here are all connected by corridors or joined directly. It is possible, therefore, to see the whole complex as a continuum of interior spaces. It does not really matter whether the buildings are aligned or at some angle to each other. All that is important is what other buildings any given building is connected to. In determining the layout of the Honmaru compound, only the need to create certain combinations of interior spaces and matters of function such as structural and lighting requirements have been taken into account (Inoue 1969). This is exactly an expression of human movement in the configuration of buildings and spaces.

This logic of movement-space structure offers proof for the assertion of the literary critic Shuichi Kato to which I referred to in the previous chapter, that "Japanese people see the whole world from here, not from the whole of world order, see the part = Japan = here. The structure, or the Japanese way of looking at things ... does not appear to have changed fundamentally" (Kato 2009). In addition, this viewpoint "human movement → parts precede the whole" plays an extremely large role as

characteristic of the Japanese way of architectural composition and architectural space. Specifically, it could support my assertion that a composition would be completed from parts in order to compose a whole.

In his work *Space in Japanese Architecture*, Mitsuo Inoue summarizes the characteristics of "movement-oriented architectural space," or "movement space" for short, as follows:

a) In movement space, it is important to note that, unlike geometric spaces, the positions (i.e., the coordinates) of compositional elements relative to some overall framework are unimportant; instead, what is important are the positions of elements relative to each other.

b) In movement space, the spatial components are observed successively (not at a single glance), which is induced by bending the movement path or by obstructing the line of vision.

c) The observation of movement space, therefore, is always postulated on the basis of the viewer's movement, whether actual or imagined.

In the strolling-type garden of the Katsura Imperial Villa, I have described in detail how the garden is configured from each part in the chapter "Parts Precede the Whole/'Now = Here' Principle." Each flexible compositional element or component is taken and bound up by one's movement and becomes integrated. It may be said that this logic of movement space is certainly the compositional principle that each part should be integrated and the whole should be composed.

## Practice of Architect Fumihiko Maki: Group Form

I have already mentioned Fumihiko Maki's work, Daikanyama
Hillside Terrace. In this project, throughout all seven phases, and
in creating the total figure of the whole project from the outputs
of each phase, so to speak from parts, Maki developed the forma-
tion and shaping of the townscape based on the compositional
concept of "group form."

The idea of "group form" has its origins in "genetic form," the
technique that constitutes a whole village by connecting box-
type buildings and which Maki came to know during while he
conducted his research in the islands of the Aegean Sea in the
late 1950s (Kawamukai, website). Maki, who had been study-
ing in the United States in the early 1960s, established friendly
relations with each member of Team Ten and searched for new
urban and architectural space that was more regional, more hu-
man, and more oriented toward human behavior. After returning
to Japan with all these experiences, he started the Daikanyama
Project. At first, he tried to design new buildings according to
the concept of "genetic form" but soon recognized the limit of
connecting variations of an identical form or type. Based on
such reflection, the project has since developed over thirty years
in seven phases. Meanwhile, Maki has developed the concept of
"group form," which creates and combines more flexible parts
that adapt to the times and the locations. Furthermore, the the-
ory of various architectural group designs has been developed,
and multiple architectural vocabularies and grammars have been

147 Segmentation and
sense of scale.
The creation of a human-
scale cityscape has been
practiced since the first
phase. At first, the seg-
mentation of building mass
started from picking up on
the delicate changes of to-
pography, but this became
an important theme through
the entire project.

148 Unification of
coloring and variation of
materials.
The exterior finish is unified
in a whitish color and mod-
ern taste is emphasized. The
whitish color was chosen so
that shades and shadows in
the cityscape would pro-
duce the strongest con-
trasts. Finishing materials
have changed, considering
the maintenance required,
from coated concrete to

**144**

air-blast tiles, ceramic tiles, and aluminum panels, but only within the color range of white to grey.

**149  Ten-meter-high eaves line.**
To create a sense of unity in the cityscape, unification of height is important. Here, the height of the eaves line is fixed at ten meters and high-rise parts are set back.

**150  Corner entries and round corner columns.**
Corner indents, the idea of which is common to corner plazas, emphasize the entrances and bring about some changes in the exterior space. Round columns are intentionally used because they have the visual effect of producing completed independency.

accumulated. The concept of "group form" is an exact expression of the Japanese "devotion to parts" and "craftsmanship."

New architectural considerations such as spatial depth and folds came up in a specific project. By creating and aggregating together each of the elements that would form the architectural considerations, the charming present cityscape was completed. The techniques of "group form" include segmentation and proper sense of scale; unification of coloring; moderate variation of materials, corner entries, and corner plazas; independent round columns, trees, and symbiosis between nature and architecture; loop passages that bring about a sense of migration and depth; intervention of nondaily activities; and so forth. As compositional elements common in every phase (part), all of these contribute greatly to the charm of the cityscape.

In the following pages, I will describe the techniques of "group form," such as various architectural group designs, diverse architectural vocabulary, and architectural considerations.

1  Segmentation and sense of scale 147
2  Unification of coloring and variation of materials 148
3  Ten-meter-high eaves 149
4  Corner indents and round corner columns 150
5  Symbiosis with nature 151
6  Open courtyards 152

What is noteworthy at Hillside Terrace is that Maki elaborated sequential plans such as "vernacular," "locality," and multiple "linkages," and that he pursued a compositional principle and a technique that would connect each individual part, while letting it change, to bring about an identical whole; in these efforts, he was devoted to Japanese sensitivity. With their universal Modernist taste, the architectural elements that this pursuit realized definitely embody Japanese identities such as spatial depth and folds.

7 Spatial folds 153
8 Spatial depth 154

Maki has consistently created a new urban space with the architectural vocabulary of Modernism. Using the technique of "group form," which this chapter has introduced, and the vocabulary and concepts of multiple architectural group design, Maki succeeded in creating a group of architectural structures in which parts were valued and parts took precedence.

**151 Symbiosis with nature.**
Originally, this district was a residential area full of green. Such a feature has been left as untouched as possible, and it has become an urban oasis space. The green on the right of the photo is a round burial mound from the Burial Mound age. The third phase buildings (completed in 1997) are constructed around the green of this mound.

**152 Open courtyards.**
Open courts, sunken gardens, and multiple public spaces are incorporated. Such spaces induce a variety of activities.

**153  Spatial folds.**
Being able to see and not
able to see creates "spatial
folds" (Maki 2006).
These are created by an
overlapping of space such
as a corner indent and
entrance, an independent
column and a courtyard,
as well as a tree and an art
object.

**154  Sense of spatial
depth is introduced.**
Multiple "spatial folds"
create and visualize "spa-
tial depth." Here, a circuit
passage leads one to an
inner zone and the trans-
parency of the interior
through the glass is added,
and a rich "spatial depth" is
composed.

# WHAT DOES "PARTS PRECEDE THE WHOLE" ACCOMPLISH?

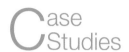

# Case Studies

I will make concrete investigations of cases that, at the present time, have succeeded to be among the most representative instances of the process of "parts precede the whole" having a notable influence.

## Nara Prefectural Office Building

This building was constructed along the main street of Nara just in front of Nara Park. It is an inspiring work designed by a diligent and skillful architect from the Ministry of Construction, Mitsuo Katayama. Katayama deliberately considered what could be most fitting for the environment of this ancient city with a history of over 1,000 years, and he carefully studied the arrangement of Buddhist temples: the gate, the surrounding corridor, the main hall, the tower, etc. 155, 156

Katayama thus came up with this design, which bears a strong resemblance to the image of the Great South Gate of Todaiji. The characteristics of his design were the deep eaves on top, the rectilinear design based on the post and lintel system, the emphasis on the horizontal lines, the multilayered arrangement to acknowledge spatial depth, and the atmosphere it evoked. These are the characteristics of traditional Japanese formative design. It was inevitable that the more Katayama tried to pursue the essential qualities of the past, the more his design took after the great heritage of Todaiji.

What is noteworthy is that, as a matter of course, Katayama did not attempt to follow the image of the Great South Gate. It is

155　Nara Prefectural
Office (built: 1965,
architect: Mitsuo
Katayama, location:
Nara).
Like a corridor, lower build-
ings surround the courtyard
in front of the high-rise,
which resembles the layout
of Todaiji Temple. It can be
said that the three-span
entrance way is quite similar
to the Great South Gate of
Todaiji.

156　Great South Gate of
Todaiji (rebuilt: 1199).
The design essence of this
structure is the emphasis on
horizontal lines, deep eaves,
independent columns, and
the multilayered arrange-
ment of spatial depth.
These features were appar-
ently inherited by the Nara
Prefectural Office Building.

the parts of the building, such as the eaves, columns, and beams,
on which he focused. They are, so to speak, the essences of tradi-
tional architecture, and it was from these essences (namely parts)
that Katayama assembled the architectural structure. As a result,
he created architecture that harmonizes with and has a suitable
presence in the traditional city of Nara. This is an exact example
of the Japanese identity that parts precede the whole.

### Makabe Denshokan

Makabe in Sakuragawa City, Ibaraki Prefecture, where the moun-
tains extend outward from Mount Tsukuba in the background,
developed as a countryside town that was home to a *jinya* (the ad-
ministrative headquarters of a small domain in the Edo period),
and the townscape of the Edo period, which can still be seen here
and there, is designated as an Important Preservation District for
Groups of Traditional Buildings.

In the center of the town, a multifunction complex—Makabe
Denshokan, consisting of a library, a multipurpose hall, and a
historical museum—was built. In the midst of the historical
townscape, a significant task was determining how to maintain
tradition and harmonize with the townscape. Using a design
method called "sampling and assembly," which extracts and
reconstructs the historical townscape elements, the architect
brilliantly succeeded in realizing this task and was awarded the
Architectural Institute of Japan, Architectural Design Division
Prize in 2012.

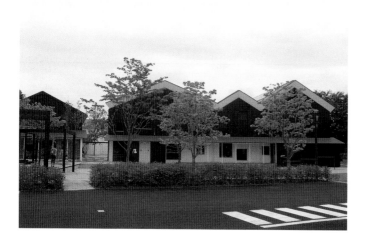

This design method uses numerous on-site investigations and measurements of the profiles of the landmark buildings that constitute the townscape. Through such a process, familiar forms and a sense of scale that correspond to the existing townscape were created, resulting in a charming facility that is completely suited to the traditional town. 157

Let's look at the contents of what is extracted by "sampling and assembly." In Makabe, traditional houses and warehouses remain here and there as the following photographs show. 158, 159

Here, I want to emphasize that this new "sampling and assembly" design method is in fact based on the traditional Japanese sense of creation that is "formative development from parts." By using the results of case surveys (from the parts), this design technique reconstitutes new architectural structures; it is thus at once an old method and a new challenge (to the whole).

157 Façade of plaza and parking space (built: 2011, architect: Makoto Watanabe, Yoko Kinoshita, Masato Araya, location: Sakuragawa, Ibaraki Prefecture).
The familiarity of triangle roofs, sense of scale, and coloration contribute to the unobtrusive presence that blends into the townscape.

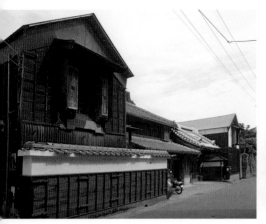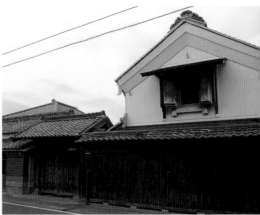

**158  Taniguchi Residence in Makabe Town.**

At first, a sense of scale of the traditional houses, dimensions of each part of the houses, the triangle roof with its characteristic slope, the horizontal line of a wall or eaves, black-board walls, and the typical window shape were extracted (refer to figure 161).

**159  Tsukamoto Residence in Makabe Town.**

The characteristic existence of a warehouse and its white plastered wall are very impressive. The townscape is characterized by black and white contrasts.

153

The design composition of the façade of the Hall Building and other parts of Makabe Denshokan is exactly what made the form, proportion, sense of scale, and coloring of traditional houses and warehouses successful. Therefore, although this is a new building, its unobtrusive presence dissolves into the traditional townscape. 160, 161

My first impressions of Makabe Denshokan were that "it exemplified Japanese beauty, with the vivid contrast between white plastered and black-board walls," and that, by clever use of the results of sampling, "the handling was quite skillful and it had achieved a fascinating sense of scale." Irregular and freely positioned windows were full of new sensitivity and seemed to be quite effective accents. The relaxing sense of scale that the courtyard between the buildings creates seems to fit the free and easy atmosphere of Makabe Town. 162, 163

160   Façade of Hall Building.
Form, a sense of scale, coloration—all come from the old townscape and therefore look very comfortable.

161   Façade of old town side.
This building completely resembles the façade of Taniguchi Residence.

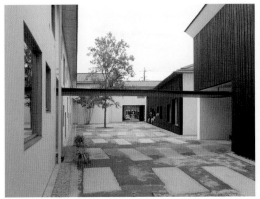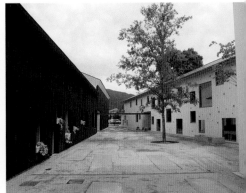

162   Courtyard (from plaza).

163   Courtyard (from entrance).

In the interior spaces as well, mountain-shaped forms were repeatedly used and irregular openings brought about unexpected effects. That is to say, because of the irregularity in their form, the openings were acknowledged, and subsequently, the green of trees and the white plastered and black-board walls came into sight in the form cut by the openings, which was quite charming. While I sat in the library's study space, I was aware of a comfort unlike that of urban libraries. The library thus realizes tasteful settings. 164, 165

The design of Makabe Denshokan is certainly a concrete example of "parts-precede-the-whole" creativity, where parts are closely examined and the best whole is developed. This should be regarded as a representative case that was produced by the resonance of the Japanese sensitivity of creation, which had been cultivated over time and through contemporary sensitivity.

## Marunouchi Redevelopment Project, Tokyo

The Marunouchi Redevelopment Project is certainly one of the most representative city planning and development projects currently being carried out in Japan. The Marunouchi district is the main gateway to Tokyo and the city's great business center; it is an area of which Japan is proud and where headquarters of representative Japanese firms and companies from all over the world are situated together. At the same time, the district is an expanding large-scale commercial area of brand-name stores and retail outlets. On weekdays and weekends, day and night, regardless of the

164   Library study space.

165   Random windows of the study space.

166 Marunouchi
Building and New
Marunouchi Building in
the rear.

167 The main street is
turned into a pedestrian
precinct (lunchtime).

time, the area is filled with all sorts of people enjoying all kinds
of activities. This is the result of the Marunouchi Redevelopment
Project First Phase (1998–2007) and Second Phase (since 2008),
which are being carried out mainly by Mitsubishi Estate com-
pany. 166, 167

Marunouchi, close to Tokyo Station and the Imperial Palace,
enjoys a superior location and the convenience of concentrated
urban infrastructure, and the district has been the main actor
in Japanese business society since the late Meiji period, when it
was called "London street block." However, in summer 1997, a
shocking article on "Marunouchi at Dusk" on the front page of
*The Nikkei* reported on the decline of facilities in the area and
noted that after 3 p.m. all shutters facing the streets were closed
because the area was mainly occupied by financial institutions,
while pedestrian traffic was sparse. The paper said Marunouchi
had lost its vitality and was a symbol of the bursting of the eco-
nomic bubble.

This article became an extremely significant turning point for Mit-
subishi Estate, which owns and manages most parts of Marunou-
chi, and a spur to commencement of the redevelopment project.
The first action was the reconstruction of Marunouchi Building,
which was completed and reopened in 2002. This was the first
effort to bring a large-scale commercial facility to Marunouchi,
and when the building opened it attracted many people and
experienced success that was reported day after day by the me-
dia. This was the first fruit of the Marunouchi Redevelopment

Project. On looking at the great flow of people, the president of Mitsubishi Estate said, "What have we been doing until now?" It was extremely impressive that, rather than saying "We did well!" to praise the successful project, the president spoke in a way acknowledging that the company had not been able to stimulate the potential of the district until then.

### The Characteristics of "Parts Precede the Whole" in the Marunouchi Redevelopment Project

As described above, the redevelopment of Marunouchi is a representative city planning and development project being carried out in Japan. I was partially involved in the design work, as a senior architect of Mitsubishi Jisho Sekkei (the design firm of Mitsubishi Estate). Here, I will look at how those Japanese characteristics that are similar to inherited creative genes appear and are activated, especially from the point of view of "parts precede the whole" or "formative development from parts."

In the course of the development of the project, it was natural that the total concept such as "creation of an interactive city" and the image of the whole picture that was the base of city planning be discussed, and of course that the overall model of the formative design—such as the size of each block, building heights, and following the thirty-one-meter line, which was the maximum height of former buildings—be shown. However, the independence and the originality of each block and building that are parts of the whole picture are well maintained, and the formative

development of the district has not become homogeneous because it was regulated by the total image. This is where we catch a glimpse of the characteristic of Japanese creativity that develops from the best practiced parts and comes up with the best possible total.

### Asymmetry/Marunouchi Building and New Marunouchi Building

When the Marunouchi Building and the New Marunouchi Building were reconstructed, many people insisted that, as seen from Tokyo Station, the two buildings should be in completely symmetrical form. From the point of view of the gate of Gyokodori Street (the street from Tokyo Station to the Imperial Palace used for official events of the Imperial family and for foreign ambassadors visiting the palace to present their credentials), opinions were in favor of a symmetrical twin tower. Numerous detailed study models including wide areas were made, and the appropriateness of a complete twin tower was discussed. Those who were in charge of the design disregarded the symmetrical figures, and the top management of Mitsubishi Estate accepted the recommendations of the designers.

The designers were aware of the fact that introducing symmetry into this site would have an immense impact on the character of the whole of Marunouchi, and they were thus as deliberate as possible. The designers tried to avoid symmetry so that the structures would not be authoritarian, artificial, rigid, and unsuitable

for the diversity so typical of the Japanese style, in addition to being inappropriate for the natural view of the Imperial Palace. They aimed to develop urban planning in which the logic of each individual block would be used effectively. Here, the sensitivity of the Japanese to eliminating symmetry is clearly shown.

As the result, the Marunouchi Building was designed by utilizing the intellectual abilities of Mitsubishi Estate's in-house architects and was completed in 2002. Five years later, the New Marunouchi Building, the basic design of which was carried out by a British architect, was completed in an asymmetrical style entirely different in its exterior finish and form. Now, in front of Tokyo Station, I am glad to see the two buildings standing as examples of quite natural taste. 168

This is a case that strongly recognizes the characteristics of Japanese culture, which do not control parts from the whole picture but develop an independent and original world in each part of the whole.

## Diversity of Each Block in the Marunouchi District

Nowadays, the given design conditions of office buildings—which are, so to speak, universal standards—are extremely uniform, and it is therefore obvious that homogeneous structures are likely to be built. If the total plan were to exist initially, the likely result would be total homogeneity due to the control and restrictions of the plan. In circumstances as in Marunouchi, however, it seems that a force to eliminate uniformity exists.

168  Marunouchi Building (left, built: 2002, architect: Mitsubishi Jisho Sekkei) and New Marunouchi Building (right, built: 2007, basic design: Michael Hopkins, architect: Mitsubishi Jisho Sekkei).
The two buildings have the same functions (office and commercial) and similar volume. Therefore, there were strong opinions that their design should be the same, as twin towers. But the architects had the courage to insist on the independence of each block, which was quite significant.

169  Restored Mitsubishi Building No. 1 (original building: built in 1894, designed by Josiah Conder; high-rise construction and restoration both completed in 2009,

architect: Mitsubishi Jisho Sekkei).

It has only been forty years since the former building was demolished because of the logic of economic rationality, and the same building was restored here as faithfully as possible. In the meantime, values had changed quite rapidly, making it likely that this change had greatly influenced architecture itself. This restoration reminds us of the history of Marunouchi and helps us appreciate a calm atmosphere in the efficiency-oriented city.

170 The Marunouchi Park Building's pocket park. This is the type of public space that has long been sought after but not realized for Marunouchi. The space is always crowded and there are refreshments, encounters, and laughter. It is an oasis for a busy city.

Each of the new Marunouchi site blocks is larger now because of the integration of smaller sites, and owner-developers had different additional requirements in each site block. Various urban planning techniques such as the specific block system, comprehensive design system, and volume transfer have been taken into account, and the requirements of those technical systems, which are enforced by the local government in order to obtain the relaxation of certain regulations, vary. As a result, the diversity of the city, or the independence of each block, has been achieved, and Marunouchi district is now a great accumulation of urban blocks, each with a theme that differs significantly from the others. Let's take a look at the characteristic blocks in this district.

### 1 Marunouchi Park Building

Marunouchi Park Building was completed in 2009. Mitsubishi Building No. 1, which was originally built in 1894 as the first office building in Maruouchi, was restored on the same site. The appearance of this nostalgic European-style building brought some relief and respite in Marunouchi, where everything is new. In addition, there is a courtyard-type public space, or pocket park, on this site, which can't be found in other blocks, and this is a place for relaxation and refreshment for office workers and shoppers. 169, 170

## 2 New Palace Hotel

The brand concept of the rebuilt New Palace Hotel is "Experience the Heart of Japan." The confidence in the beauty of Japan and the pride in how people who were related to the design respond to it are apparent in this phrase. As for the architectural design, the materials used and the spatial quality pursues modern Japanese style and Japanese sense, with planes, lines, and eaves as motifs. In Westernized Marunouchi, this was a project that had to be especially aware of Japanese identities.

The main subject of this design was how to enjoy the rich Japanese environment (the green of the Imperial Palace, the moat, the stone wall, and the vast open space), which could never be found at any other urban site. 171, 172

## 3 Preservation of old buildings 173, 174

At the start of the redevelopment of Marunouchi, buildings remaining from the Meiji period (1868–1912) did not exist, but a few from the Taisho period (1912–1926) and the early Showa period (1926–1989) remained. From the days when this district was called "London street block" in the Meiji period, Marunouchi has flourished; it used to be characteristic of the district that buildings from various periods coexisted. On the occasion of the renewal of functions of those buildings, cultural aspects, economic efficiency, and the safety of the buildings became big issues. Nevertheless, the existence of these buildings is indispensable for the diverse charm and richness of the cityscape.

171 Front lobby of main entrance.
The best way to respond to a Japanese atmosphere is to incorporate the surrounding environment. This is a picture window whose motif is the stone wall and the water surface of the Edo Castle moat.

172 Restaurant terrace seats.
In the hotel before reconstruction, there was a restaurant at the same place overlooking the moat fitted with big windows. After the restoration, the restaurant became an outdoor dining facility. Facing the stone wall, the restaurant is now a very popular spot, enjoying comfortable breezes over the water surface.

 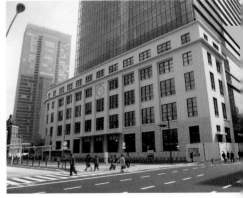

173 The Industry Club of Japan (originally built: 1920, architect: Tamisuke Yokokawa, preservation and high-rise completed: 2003, architect: Mitsubishi Jisho Sekkei). This is a full-scale preservation example that involved structure relocation, and where the main interior spaces such as the main hall and the main dining area have been completely preserved. The building stands gracefully, contributing greatly to the diverse beauty that surrounds the plaza in front of Tokyo Station.

174 Tokyo Central Post Office (originally built: 1931, architect: Tetsuro Yoshida, preservation and high-rise completed: 2012, architect: Helmut Jahn and Mitsubishi Jisho Sekkei). The appropriateness of preservation for this structure was widely addressed by the media, and public opinion was completely divided, resulting in only the façade being preserved. The existence of the old building at the eye level of people walking on the streets contributes significantly to the representation of urban diversity.

The Industry Club of Japan Hall, which was built in 1920 in a way that preserved the main interior and exterior parts, was renewed, which involved structure relocation and seismic isolation devices. By contrast, the Tokyo Central Post Office Building, which was a representative work of early Japanese Modernism built in 1931, was rebuilt after a big dispute involving the minister at the time to preserve the façade facing the plaza in front of Tokyo Station. In both cases, opinions about the design regarding the relationship between the high-rise part and the lower part are divided, but there is no doubt that these buildings contribute greatly to the cityscape's diversity.

## Marunouchi Nakadori Street

It can be said that the main character of Marunouchi is neither the Marunouchi Building nor the New Marunouchi Building, but Nakadori Street. This street is always crowded with people due to the accumulation of many brand-name shops which are likely more numerous than those on Ginza Street. It has only been eighteen years since the appearance of the shocking article on "Marunouchi at Dusk," which reported that on Saturday afternoons all the shutters facing the streets were closed because the area was mainly occupied by financial institutions and that pedestrian traffic was sparse. Here, the importance of urban development planning is certainly recognized.

Nakadori Street runs through the main blocks of Marunouchi and, being unified with each block and sharing the independent

175 **View of Nakadori Street penetrating Marunouchi.**
Nakadori Street penetrates the main blocks of Yurakucho, Marunouchi, and Otemachi, which form Tokyo's central business district. Alongside this street, first and second floors are occupied by global brand shops, whereas the high-rises above them house the newest office facilities.

176 **Change of street image from financial offices to retail shops operated by global brands.**
It has been but less than twenty years since the ground floors of all buildings along this street were dominated by financial institutions such as banks and securities and insurance companies, meaning

that after 3 p.m. or on Saturday afternoons, all shutters were closed and pedestrian traffic was sparse. Drastic changes have been made and this is now a very popular spot where it is crowded 365 days a year with office workers, shoppers, and sightseeing visitors.

**177 The main players are now people.**
Nakadori Street develops in multiple ways according to the theme of each block it faces. The street consists of parts that fit into each block. Activities of each individual block spread out on to the street. Buildings including an open café, a cake shop, a chocolate shop, a flower shop, etc. create the characteristic atmosphere of the block.

**165**

concept of each block, it has developed as an attractive thoroughfare along its full length. By mixing hardware and software—such as the original pavement, street trees, flowers in each season, touring exhibits of sculptures and artworks, various events, and street performances—Nakadori Street has grown to be a representative scene of Marunouchi. The street has been incorporated into the redevelopment or the renewal project of each block through which it passes, and each part of the street is being renewed according to the block it faces. But as a whole, it has developed to become a particularly attractive street. 175, 176, 177

As can be seen above, Marunouchi continues to redevelop with the mind-set of Japanese sensitivity. Such architectural features as the diversity of each block (which is a part of the whole of Marunouchi), various schemes and arrangements, and the moderate design, which can be said to be a kind of tacit knowledge, are apparent. Many city planners from around the world participate in the development of mainland China and promote designs that are drawn straight onto blank white paper. But in Marunouchi, each block has been designed elaborately and there is a linkage or profoundness in which one scheme leads to a new device in the next stage. Secondary streets within each block crossing Nakadori Street, which runs through the main blocks, create spatial folds in the cityscape by bringing in new solutions. An underground pedestrian network has been constructed and, together with the schemes in lower-level floors, three-dimensional arrangements have been added and spatial depth has been created. Tremendous

energy has been put into the parts, and by putting them together, an immensely attractive urban development has been created. This is certainly a case where Japanese sensitivity can be clearly recognized.

What the new Marunouchi is aiming for is not a regulated orderly cityscape, but rather an aggregate of diverse and attractive parts, which, in a sense, corresponds to the former description "The townscape of Edo, as seen on the map, is nothing but an aggregate of multiple parts" ("Parts Precede the Whole/'Now = Here' Principle").

# My Design Work on Nibancho Garden

An example of "formative development from parts" was my personal design work in the Nibancho Garden Project. This was a large-scale development project in the middle of Tokyo, consisting of office space (B2F–9F) and residential floors above (10F–14F), the total area of which was over 57,000 square meters. I was in charge of designing and promoting the project.

In one direction, the project site faced commercial areas connected to Shinjuku Street, but in the other three directions it was surrounded by the quiet and distinguished residential environment of Sanbancho, Chiyoda Ward. Here, many companies, including Dai-ichi Life Insurance and Mitsubishi Estate, owned a vacant lot for development that was over 11,000 square meters in size and partly being used as a material storage site. During the bubble economy, a skyscraper project was planned utilizing various urban planning techniques and mitigations of restrictions. But, as can be clearly seen on the site plan shown below, due to the sense of scale that was so different from the surrounding environment and the sense of incongruity with the quiet residential area, the project was stopped. In other words, project was abandoned as a result of the logic of a master plan for large-scale architecture. 178 The twenty-first century began and the construction circumstances eased, and therefore we gradually restarted the project. But from the developer's standpoint, a large-scale building was inevitable. From the logic of economic rationality, utilizing the maximum floor area permitted was a matter of course. The neighborhood reacted negatively to the news that the project was being

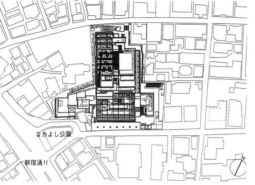

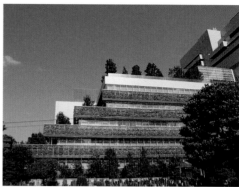

restarted, and the head priest of an adjacent prestigious temple said he would object by raising straw mat flags. The most significant subject was how to respond to the various situations of the neighbors and how to design a plan that would fit into the surrounding environment. The method we adopted here could certainly be described as "formative development by way of creating the best parts and coming up with the best whole."

Here, I will look at our actual design, which was created by realizing the characteristics of Japanese identities that I feature in this book.

178  Site plan.
The scale difference in the size of the project area is obvious. It is quite important to preserve the continuity of the townscape, and we restarted the project with the recognition that the main design theme was how to fit it into the surrounding environment.

179  Coexistence with neighboring graveyard (built: 2004, architect: Mitsubishi Jisho Sekkei, location: Chiyoda-ku, Tokyo).
What should the building look like as the background for the graveyard? Starting from this point of view, we came up with this tremendous green wall, like a green hill. This greening was indispensable for the graveyard's coexistence with the temple.

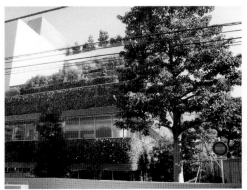
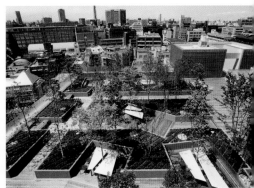

**180  Setbacks on the north side.**

The total form accords with the north side set-back line, and the combination of the setbacks and plants is quite effective. The arrangement of scale differences and the reduction of oppressive feelings in these parts of the building are apparent.

**181  Open-air office.**

At the time, the idea of an open-air office was considered very new and attractive. The open-air activities in good weather were especially refreshing. The pursuit of such additional values in each part of the building contributed greatly to the total evaluation of the building.

## 1 Intimacy with Nature

In order for the new building to blend in with surrounding buildings whose scale and functions are completely different, what we first considered was to let nature be the medium. We brought in as much green as possible and aimed to coexist with the neighbors by means of intimacy with nature. We aimed to rely upon the common characteristic of the Japanese that is "coexisting with nature."

The starting point of the design was how to correspond to the temple and its graveyard in the west. 179

As for the north side, we planned set-back terrace gardens with abundant plants on each floor, thus creating a new urban scene as if a green hill had appeared. 180

Such an attitude in pursuit of a natural environment and comfort benefited not only the neighbors but also those working in the building. The roof garden is not merely an open space on the roof but is meant to be an open-air office, equipped with chairs, benches, tables in between plants, and LAN wiring infrastructure for use as a relaxation space or for conferences and meetings, weather permitting. 181

## 2 Insistence on Materials

We were especially particular about the constitution of the green wall. What should be planted, how it should be unified, the maintenance management system, and so forth. We put an extraordinary amount of energy into searching for answers to each of these questions. Constructing a green wall as the exterior finish of a building in the city center with an area of over 700 square meters, on the west and north sides, and from the second to the sixth floor, was an unprecedented challenge at the time. 182

Through thorough examination, we selected the evergreen *Hedera canariensis*, which is a kind of climbing plant. We understood that its green color was beautiful and the leaves were shiny, and it was disease-resistant and good in dry conditions. In order to raise the green coverage rate at the time of the building's completion, we grew the plants in advance in units made by unifying stainless wire mesh and planters, to then finally hang those units as the exterior finish on site. An automatic water sprinkler system and labor-saving management system were also installed.

Such a serious approach is simply the appearance of the characteristic of Japanese identities that is insistent on materials and tries to maximize their merits.

182   Green wall and unit system.
I was especially nervous about the actual green coverage rate at the time of the building's completion. I wanted it to be over 80 percent and, as can be seen in this photo, I adopted a 90 cm × 90 cm greening unit system and increased the green coverage area by growing the plants in advance at a separate site.

183 South elevation.
The south elevation facing the road that leads to Shinjuku Street is the façade of an office building. While a dignified style and functionality as an office building were considered, horizontal louvers were for the relief of the visual line looking down from the office windows to the low residences on the other side of the street. This was why the louvers were placed under the glass windows, not above. The façade of the upper five stories in use for office and residential floors were slightly set back to reduce the feeling of pressure on the front street. Therefore, these stories cannot be seen in this photograph.

### 3 Simplicity and Denial of Ornamentation
The considerations for the neighborhood were treated as the top priority, and the design motifs were limited to those corresponding to the needs of the neighbors. By ignoring all decorations that were not necessary, we made the total design of the building extremely concise and simple.183

## 4 Diverse Sensitivity and Japanese Taste

While aiming to design simple architectural structure, we decided to introduce Japanese taste so that the architecture would more positively dissolve into the gentle residential area that had existed since the Edo period. On the east side, where residential neighbors were very close, we designed a calm space called the "green passage" in the Japanese sense situated in-between the existing neighborhood and the new building, and on the windows above, we designed screens which resemble bamboo blinds made of porous bent plate in consideration of privacy for the neighbors. 184
In the formative design, the Japanese sense was adopted here and there, and the aim was to relate it to the atmosphere of the region. The entrance gate overlapped the characteristics of a wooden structure similar to that of the Great South Gate of Todaiji, which I have described above. 185

184 Thoroughfare through the site called the "green passage."
A passage from north to south through the site and open to the public was required by the local government. In response, a public open-space passage in Japanese rock garden style was created on the east side.

185 Entrance gate.
This part of the structure had only the function of leading people into the building. Pursuing a Japanese sense as a subtopic had several results: big, deep eaves; emphasis on horizontal lines; and slim pillars.

186 East elevation.
On the east side adjacent to the site, there were individual houses. Here, for the purpose of maintaining their privacy, we put bamboo blind-like screens made of porous bent plate in front of the windows on the second to fourth floors of the offices, as seen in the photo. The view from the windows of the office became half-transparent, but that did not cause any discomfort.

## 5 Spirit of Coexistence 186

As for the design of the building, there was the green wall; terraces that were set back, like the façade; the greening of the roof; horizontal louvers; the bamboo-blind-like screen; segmentation on each elevation; Japanese taste; and so on.  As a result of corresponding to each part the building faces, the total configuration was as if anything could be there. The sense of feeling comfortable in a style in which anything goes and the ability to create the best by unifying those parts is the spirit of coexistence of the Japanese.

## 6 Asymmetry 187

We Japanese do not have the disposition to pursue a symmetrical figure unless there is a particular intention. Besides, in this case, under such complicated conditions resulting from the shape of the site, we would never consider a symmetrical figure when designing a building. In addition, in trying to satisfy as far as possible the various requirements of the neighbors at each part of the site, symmetry of the total figure is impossible.

## 7 Culture of Addition

In the chapter of this book devoted to addition, I said that the culture of "formative development from parts to the whole" was in a sense the "culture of addition." The development of the plan for Nibancho Garden was this "culture of addition." The plan (fig. 190, page 176) clearly shows that the building is the result of the addition of functions and utilization of the site according to its shape. Here, the characteristics related to the orthogonal design pattern and techniques of connection, which I mentioned in the chapter on addition, are clearly demonstrated. It can be said that the main entrance hall is, in this case, a connecting space that became internal.

187   Bird's-eye view from the east.
As a result of unifying the land of the owners, the shape of the site was complex. We gave top priority to corresponding to the neighbors who were facing the site on each side, and a symmetric picture of the whole was therefore never considered.

## 8 Sense of *Oku* 188, 189

After going through the entrance gate and going up, visitors make a right turn to enter the main entrance hall. From there, the view ahead is blocked and the office zone is seen through the big glass window on the left. (Refer to fig. 190, page 176.) This is the sense of *oku* expressed in the space of approach to Ginkakuji Temple and Nezu Museum, to which I referred to in the chapter "Sense of 'Oku = Inner Zone.'"

In this chapter, I looked back at how we had been engaged in embodying the characteristics of what are often called Japanese identities in our design of Nibancho Garden. In the background of the embodiment of these characteristics, I strongly recognize the existence of the idea that "parts precede the whole."

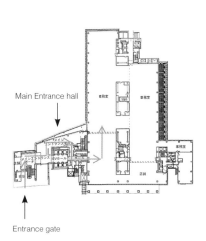

Main Entrance hall

本秘室   本秘室

本秘室

エントランス
EVホール

店舗

Entrance gate

## 9 From the Parts to the Whole

We tried to do our best in designing the building, taking into consideration as far as possible the requirements of its neighbors. Because the circumstances of each neighbor differed, it was necessary to respond in a completely different way at each part of the building in each elevation. We thus tried to do the best at each part of the building, and as a result, the total figure was completed "from parts to the whole." In any case, the priority was that the completed building be attractive and show maximum functionality. Although this was a huge office building with a volume of over 57,000 square meters and residential floors above, a distinguished company was greatly in favor of the environmentally friendly design policy of the building and its performance, and the entire office area was rented under an extremely long contract. From the developer's point of view, the project was a great success. We also earned high marks from the neighbors, and, coinciding with the project's completion, we were awarded the design contract for the reconstruction of the guest hall and living quarters of the adjacent temple by the same head priest who had once said he would oppose the project by raising straw mat flags.

What we especially had in mind for this project was the sense of scale on the site. For this purpose, so that each part would have the right scale, the entrance gate, elevator shafts, staircases, and other parts jutted out from the main structure, and the total exterior appearance seemed like a row of small buildings. Although it was a single building, the exterior view was as if a complex

190   2F plan.
Main Entrance Hall ↓
Entrance gate ↑

191   Bird's-eye view
from the west.

of many small buildings had been constructed. The plan clearly shows this. 190

As can be seen in the photo, the entrance gate and the elevator tower in the west look as if they are different buildings. The high-rise part in the front and the lower part in the back are the same. The protruding part in the east looks like an annex building. Within the total structure, there is a convenient 50 meters × 100 meters of office space in a useful rectangular plate. 191

The entrance gate in the west is a separate building that could be called an entrance annex. Its appearance is quite suitable for the entrance, and it has the properly segmented scale and appears as an independent existence. Although not straight, the traffic line for the entrance of the building is clear. 188

At the beginning of the chapter "Parts Precede the Whole/'Now = Here' Principle," I wrote:

> Japanese architecture is designed from parts and then configured as the whole. In other words, no total picture is imaged at the beginning, and parts are created one by one in the most proper way; as a result, the best possible total is produced as the whole. This procedure is quite different from the Western way of creating.

In the Nibancho Garden Project we pursued and practiced this distinctly Japanese procedure.

# SUMMARY

What is at the root of Japanese creativity? What makes Japanese architectural artifacts different from those of Western world? In this book, I have tried to describe and verify the root of Japanese architectural characteristics.

I show about 180 photographs which I myself have mostly taken. The quantity of information that these photographs communicate is enormous and should be quite useful in helping readers stimulate their imagination and creativity. I have tried to describe the logic, interpretations, and explanations of Japanese creativity through words and to show their reasons through photographs. I hope that various interpretations and ideas that readers might glean from these photographs will deepen the understanding of Japanese creativity.

My first challenge was to organize existing ideas and studies on distinctive features of Japanese architecture. I identified twelve architectural characteristics and enabled comprehensive arrangements of Japanese architectural features that have often been talked about only individually.

By taking into account the twelve characteristics at the same time, it became possible to grasp comprehensively the whole picture of Japanese architecture. And by giving priority to the bird's-eye point of view, I looked at the mutual relationships among the characteristics and what was behind them. I introduced the core understanding of Japanese creativity that "parts precede the whole," through which it became easier to explain these characteristics.

My next challenge was to verify the hypothesis that "Japanese architecture is designed from parts and then configured as the whole." In other words, no total picture is imaged at the beginning, but one by one, parts are created in the most appropriate way, and as a result, the best possible total as the whole is produced. I went through various old and new structures and concluded that structures designed by the "parts-precede-the-whole" process, which were quite different from Western culture, bore the following characteristics:

- Great importance is attached to the elaborate works and devices of each part of the whole.
- The total form is regulated by the mutual relationships between parts (especially adjacent parts) and how parts are connected.
- The awareness of the whole of each part is obscure.
- The whole is the result of the accumulation of each part.

I also investigated present-day cases that succeeded in the creative process that "parts precede the whole," and which have notable influence at each respective level of single architectural structures, architectural groups, and urban planning.

And finally, I came up with a way to interpret and explain Japanese creativity as a whole. The multiple characteristics of Japanese creation that I described in this book, which have been succeeded in being mutually influenced, are shown in the following diagram. From the bird's-eye view of comprehensive considerations, the idea that "parts precede the whole" is placed in the center, and

the mutual relations among the Japanese architectural character-istics I examine in this book are expressed in the diagram. The inheritance of such Japanese architectural characteristics is simple proof of the expectation that something is there to be successfully realized, namely, the existence of what is at the root of Japanese creativity.

Through the intervention of the idea that "parts precede the whole," it was shown that the Japanese architectural features that had been discussed respectively and separately were mutually re-lated to one another, and a way to interpret and explain Japanese creativity as a whole was to be found.

- The lifestyle of the Japanese that is "the way of symbiosis with nature" leads to the "now = here" principle and connects to the idea of "parts precede the whole," which developed "asym-metric and organic forms."

- The spirituality that leads to simplicity is likely to eliminate decorations that bind the whole together, and to pay attention to parts; and as a result of well-honed parts, this spirituality is considered to have become more devoted to "small space."

- From the spirituality of "coexistence/anything goes," it is pos-sible to explain that "parts precede the whole" without being conscious that overall control is likely to be practiced, and subsequently more importance is attached to "now = here," and to the attitude of concentrating on what is in front of the eyes rather than showing the whole that is brought about by a specific "not-to-show-the-whole" form.

The fact that each of the twelve characteristics could be explained in relation to the understanding that "parts precede the whole" is quite important in order to describe Japanese creativity as a whole. It is difficult to explain the origins of the peculiar Japanese sense of *oku* and its appearance in architecture, but from the approach that "to see the whole from now = here," it can be explained that the close-up of the relative zone/depth in space leads to the specific concept.

In closing, I want to mention that the attempt to accomplish the extraction of the characteristics and the comprehension of the total picture of Japanese architectural artifacts is, in a sense, a logical development based on sensitivity that has not been examined in the form of a logical study thus far. But what I recognized through my experience as an architect was that considerations of the characteristics of Japanese architecture and what lies in its background are closely related to the understanding of Japanese architecture and also applicable and useful in the actual design phase.

# Summary Diagram

**What is at the Root of Japanese Creativity: Japanese Identities**

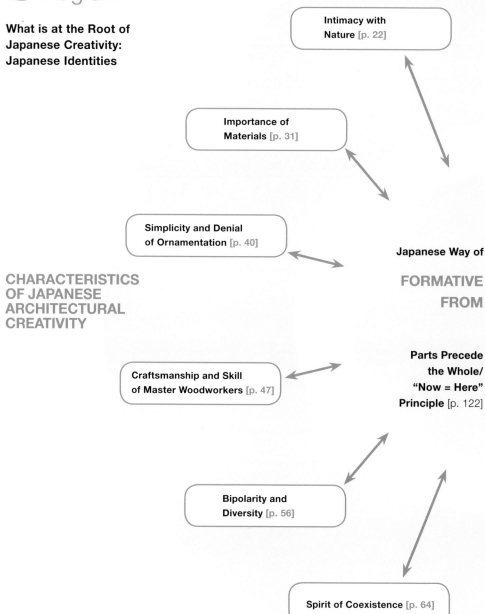

Intimacy with Nature [p. 22]

Importance of Materials [p. 31]

Simplicity and Denial of Ornamentation [p. 40]

CHARACTERISTICS OF JAPANESE ARCHITECTURAL CREATIVITY

Japanese Way of

FORMATIVE FROM

Craftsmanship and Skill of Master Woodworkers [p. 47]

Parts Precede the Whole/ "Now = Here" Principle [p. 122]

Bipolarity and Diversity [p. 56]

Spirit of Coexistence [p. 64]

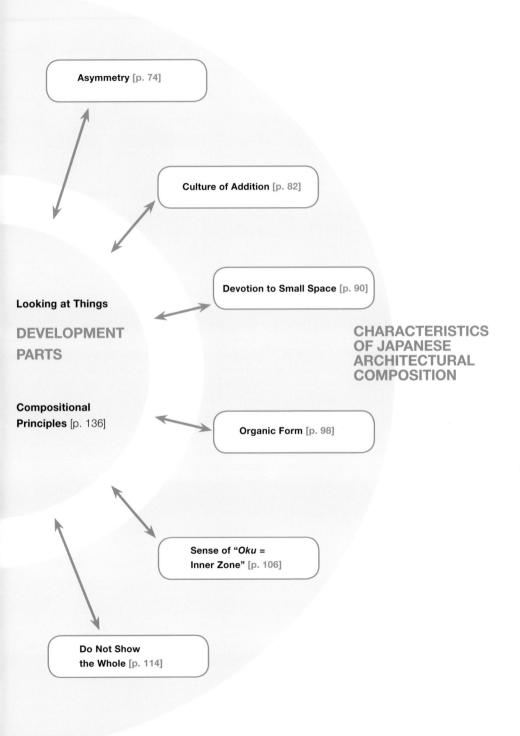

Asymmetry [p. 74]

Culture of Addition [p. 82]

Devotion to Small Space [p. 90]

Looking at Things

DEVELOPMENT
PARTS

CHARACTERISTICS
OF JAPANESE
ARCHITECTURAL
COMPOSITION

Compositional
Principles [p. 136]

Organic Form [p. 98]

Sense of "*Oku* =
Inner Zone" [p. 106]

Do Not Show
the Whole [p. 114]

# Author

## Yuichiro Edagawa, PhD (Engineering)

Globeship Corporation
Managing Director
Globeship Sodexo Corporate Services K.K.
Representative Director and CEO

1948 Born in Kobe, Hyogo Prefecture
1967 Entered the University of Tokyo,
College of Arts and Sciences
1970 Studied at the University of California, Berkeley, College of Environmental Design
1974 Graduated from the University of Tokyo, Faculty of Engineering, Department of Architecture
Joined Mitsubishi Estate Company Ltd.—Architectural Design Division
2001 Transferred to Mitsubishi Jisho Sekkei Inc. upon its establishment
2008 Resigned from Mitsubishi Jisho Sekkei Inc. and entered FM business
2009 Joined Birudaiko Co. Ltd. as a Director

2015 GLOBESHIP Corporation established, Managing Director
2016 Awarded the degree of doctor of engineering by the University of Tokyo, specializing in architectural design
Globeship Sodexo Corporate Services K.K. established, inaugurated as the Representative Director and CEO

### Qualifications
Authorized First Class Architect, Interior Planner, Certified Facility Manager

### Affiliated academic societies and others
The Architectural Institute of Japan, The Japan Institute of Architects, Japan Guide Association

### Representative architectural works
Tokyo Stock Exchange Building, HSBC Tokyo Building, Shochiku Square, Mitsubishi Heavy Industries Shinagawa Headquarters

Building, Nibancho Garden, Osaka Stock Exchange Building, Sankei Breeze Tower, and others, many of which have been awarded architectural prizes

**Major writings**

*Japanese Identities – Architecture between Aesthetics and Nature.* Berlin: JOVIS, 2008.
*Japanese Identities – Japaneseness through Architecture.* Tokyo: Kajima Shuppankai, 2009.
*Distinctive Features of Japanese Architecture and What is at the Root of Japanese Creativity.* Tokyo: Kajima Shuppankai 2017.

**Recent Activities**
Through FM services, making efforts in pursuit of contributions to the global environment that GLOBESHIP aims to achieve and of quality of life, which is the company policy of Sodexo with which we jointly established the JV.

In addition to the writings mentioned above, devoting time to introducing Japanese culture to foreign countries through architecture and giving lectures such as "High-Level Guiding Skill of Japanese Culture," hosted by Japan Tourism Agency; the Japan Guide Association sponsorship "Training for Understanding Japanese Architecture" for professional guides; and "The Characteristics of Japanese Architecture" to foreign architects groups visiting Japan.

# List of References Cited

"21 seiki: Nippon no kenchiku" (21st century: Japanese architecture.) Editorial supervision by Series "20 seiki: Nippon no kenchiku" Project Team. Published by Nikkan Kensetsu Tsushin Shinbunsha (2004).

Echigo Hillside Park, website. "Ten-chi-jin no fori" (Folly of ten-chi-jin). http://echigo-park.jp/guide/health-zone/folly/index.html. Accessed March 20, 2018.

Edagawa, Yuichiro. *Japanese Identities: Architecture Between Aesthetics and Nature.* Berlin: jovis, 2008.

———. *Kenchiku wo toshite miru nihon rashisa* (Japanese identities). Tokyo: Kajima Shuppankai, 2009.

Hara, Hiroshi. *Kenchiku ni nani ga kanouka* (What is possible through architecture?) Tokyo: Gakugei Shorin, 1970.

Ikebana Koryu-Rion-Kai, website. "Ikebana yogo no kiso chishiki" (Basic knowledge of Ikebana terms). http://ikebana-koryu.com/basick-nowledge-ikebana/. Accessed March 20, 2018.

Ikebana Ikenobo, web site. "Ikenobo no ikebana/Shoka shofu tai" (Flower arrangement of Ikenobo/ Shoka shofu tai). http://www.ikenobo.jp/ikebanaikenobo/ikebana/shoka.html. Accessed March 20, 2018.

Inoue, Mitsuo. *Nihon no kenchiku kukan* (Space in Japanese architecture). Toyko: Kajima Shuppankai, 1969. Translated by Hiroshi Watanabe as *Space in Japanese Architecture* (New York: Weatherhill, 1985).

Ito, Teiji. "Katsura ga gendai wo gyoshi shiteiru node aru" (Katsura is watching the contemporary). In *Katsura rikyu* (Katsura Imperial Palace), Tokyo: Shinkenchikusha, 1996.

———. *Nihon dezain ron* (Study on Japanese design). Tokyo: Kajima Shuppankai, 1966.

Kato, Shuichi. *Nihon bungakushi josetsu* (A history of Japanese literature). Tokyo: Chikuma Shobo (1999, originally published 1979). Translated by Don Sanderson as *A History of Japanese Literature* (Richmond, Surrey, England: Japan Library, 1997).

———. *Nihonbunka ni okeru jikan to kukan* (Time and space of Japanese culture). Tokyo: Iwanami Shoten, 2007.

Kawamichi, Rintaro. *Gankokei no bigaku* (Aesthetics of flying geese pattern). Tokyo: Shokokusha, 2001.

Kawamukai, Masato, website. "Gallery of contemporary architecture." First posted April 28, 2003; accessed March 20, 2018.

Maki, Fumihiko. *Miegakure suru toshi* (Hidden essence of urban design). Tokyo: Kajima Shuppankai, 1980.

———, ed. *World of Hillside Terrace + The West Annex.* Tokyo: Kajima Shuppankai (2006).

Naoshima Fukutake Bijutsukan Zaidan (Naoshima Fukutake Art Museum Foundation). *Teshima Art Museum Handbook.* Naoshima: Naoshima Fukutake Bijutsukan Zaidan, 2011.

Nishioka, Tsunekazu, Koin Takada, and Shigeru Aoyama. *Yomigaeru Yakushiji Saito* (Rebuilding of Yakushiji Temple West Pagoda). Tokyo: Soushisha, 1981.

Ota, Hirotaro. "Nihonkenchiku no tokushitsu" (Characteristics of Japanese architecture). In *Nihon no kenchiku* (Japanese architecture). Tokyo: Shokokusha, 1954.

Suzuki, Kakichi. "Daigaran no shukumei ni nozomu" (Challenge to the destiny of the great temple). *Geijutsu Shincho* (December 2009): 42–53.

Figs. 60 and 105: Miyamoto, Kenji. *Zusetsu: Nihon kenchiku no mikata* (Illustrations and texts of Japanese architecture). Kyoto: Gakugei Shuppansha, 2001.

Figs. 67 and 69: Kawamichi, Rintaro. *Gankokei no bigaku* (Aesthetics of flying geese pattern). Tokyo: Shokokusha, 2001.

Fig. 72: Azuma, Takamitsu. *Nihonjin no kenchiku kukan* (Architectural space of the Japanese). Tokyo: Shokokusha, 1981.

Fig. 74 : Imperial Household Agency. "Brochure of Kyoto Imperial Palace." Date not available.

Figs. 79 and 99: Nishi, Katsura. *Nihon no teien bunka* (Japanese garden culture). Kyoto: Gakugei Shuppansha, 2005.

Fig. 87: Sinkenchiku 01, 2000. Tokyo: Shinkenchikusha.

Figs. 90 and 91: Toyo Ito & Associates, Architects. *Kenchiku – hisenkei no dekigoto* (Nonlinear architecture). Tokyo: Shokokusha (2002).

Fig. 94: Shinkenchiku 01, 2011. Tokyo: Shinkenchikusha.

Fig. 101: Shinkenchiku 11, 2009. Tokyo: Shinkenchikusha.

Fig. 137: Maki, Fumihiko, ed. *World of Hillside Terrace + The West Annex.* Tokyo: Kajima Shuppankai (2006).

Fig. 138: Editorial Board of Japanese Architectural Chronology. *Zusetsu Nihon kenchiku nenpyo* (Illustrated Japanese architectural chronology). Tokyo: Shokokusha, 2002.

Fig. 139: "'Ippen Shonin Eden' (Illustrated biography of Monk Ippen), National Treasure, Kamakura Period (1185–1333)." National Diet Library Digital Collections.

Fig. 140: Wikimedia. "Revised map of Edo, Koka period (1844–1848)."

Fig. 143: Matsumoto City Government, website. "National Treasure: Matsumoto Castle." http://youkoso.city. matsumoto.nagano.jp/wordpress_index-p_192-htm. Accessed March 20, 2018.

Fig. 146: Inoue, Mitsuo. *Nihon no kenchiku kukan* (Space in Japanese architecture). Toyko: Kajima Shuppankai, 1969. Translated by Hiroshi Watanabe as *Space in Japanese Architecture* (New York: Weatherhill, 1985). Plan of ceremonial and domestic buildings, 1640 (According to Akira Naito).

Figs. 178 and 190: Shinkenchiku 08, 2004. Tokyo: Shinkenchikusha.

All photographs by the author Yuichiro Edagawa, except of:

Fig. 13: Wikipedia (Berthold Werner)

Fig. 24, 25: Jingushicho

Fig. 37: Computer graphic of restored interior presented by Byodo-in Temple

Fig. 38, 39: Website of Chusonji Temple

Fig. 44, 45: Brochure of Zuihoden

Fig. 50: Wikimedia Commons

Fig. 51: Togudo Dojinsai, Rokuonji Temple by Toppan Printing

Fig. 54: Wikipedia (Luca Volpi)

Fig. 62: Brochure published by Imperial Household Agency

Fig. 71: Wikipedia (public domain)

Fig. 75: Brochure of Myokian Temple

Fig. 84, 127, 128, 129: "Katsura rikyu" (Katsura Imperial Villa), Shinkenchikusha

Fig. 106: Wikipedia (663 highland)

Fig. 116: Wikipedia (David Iliff)

Fig. 118: Wikipedia (Gambitek at Polish Wikipedia)

Fig. 134: Wikipedia (Martin Durrschnabel)

Fig. 141: Website of Ikebana Ikenobo, "Ikenobo no ikebana/ Shoka shofu tai"

Fig. 144: Copyright-free image on Internet

Fig. 171, 172, 181, 182, 186, 187, 188, 189, 191: Mitsubishi Jisho Sekkei

Fig. 185: Shinkenchiku 08, 2004

Other figures are listed on "List of Illustrations Cited."

# Imprint

Texts by kind permission of the author
Pictures by kind permission of the photo-
graphers/holders of the picture rights

Cover image: Teshima Art Museum

Copy-editing: Michael Thomas Taylor
Design and setting: Susanne Rösler, jovis
Lithography: Bild1Druck, Berlin
Printed in the European Union

Bibliographic information published
by the Deutsche Nationalbibliothek
The Deutsche Nationalbibliothek lists
this publication in the Deutsche National-
bibliografie; detailed bibliographic data are
available on the Internet at
http://dnb.d-nb.de.

jovis Verlag GmbH
Kurfürstenstraße 15/16
10785 Berlin

www.jovis.de

jovis books are available worldwide in
select bookstores.
Please contact your nearest bookseller or
visit www.jovis.de for information con-
cerning your local distribution.

ISBN 978-3-86859-508-6